Classic Still Life
Painting

Classic Still Life Painting

A Contemporary Master Shows How to Achieve

Old Master Effects Using Today's Art Materials

Jane Jones

Watson-Guptill Publications/New York

This book is dedicated to John Gaddis, my incredible husband, best friend, and partner through this wonderful journey that is our lives.

Please note: Great care has been taken to reproduce the colors in this book faithfully. However, because color reproduction is not always entirely accurate, there may be minor variations between the colors reproduced here and the colors purchased as art supplies.

Senior Acquisitions Editor: Candace Raney
Project Editor: Anne McNamara
Designer: Sivan Earnest
Production Manager: Ellen Greene
Photography by John Gaddis and Brian Birlauf

Published in 2004 by Watson-Guptill Publications,
a division of VNU Business Media, Inc.,
770 Broadway, New York, NY 10003
www.watsonguptill.com

Library of Congress Cataloging-in-Publication Data

Jones, Jane.
 Classic still life painting : a contemporary master
shows how to achieve old master effects using
today's art materials / by Jane Jones.
 p. cm.
Includes bibliographical references and index.
 ISBN 0-8230-3448-8 (pb)
 1. Still-life painting—Technique. I. Title.
ND1390.J66 2004
751.45'435—dc22

 2004001688

Manufactured in Malaysia

1 2 3 4 5 6 7 8 9 / 11 10 09 08 07 06 05 04

title page:
Sassy Solo
**Oil on hardboard,
12 x 16 inches**

Acknowledgments

I want to thank my friends and family for all of their support, encouragement, and patience while I was writing this book. They have all been fabulous.

My friend Arleta Pech encouraged me to believe that I could do this project, and was unwavering in her support throughout. David Pyle from Winsor & Newton and Robert Gamblin from Gamblin Artists Colors Co. were very generous in supplying technical support and information whenever I requested. Their expertise on how to create a stable painting is incredible. They answered every question patiently, clearly, and without hesitation.

Laurentia McIntosh was very generous with her doctoral information about Maria van Oosterwyck. What a jewel she was in my discoveries.

The people at the Jefferson County Library of Colorado were wonderful about obtaining every book I asked for.

Thanks to Candace Raney for taking this project on and for giving me the opportunity to work with all the wonderful people at Watson-Guptill Publications. Having Anne McNamara as the editor was an unexpected delight. Where my writing was inelegant, she made it lovely and seamless.

 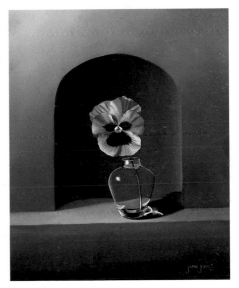

Protected Pansy I,
Collection of Gil Rotstein;
Protected Pansy II,
Collection of Clark Olsen; and
Protected Pansy III,
Collection of Bill and Barb Berkley.
Each, Oil on hardboard, 13 x 11 inches

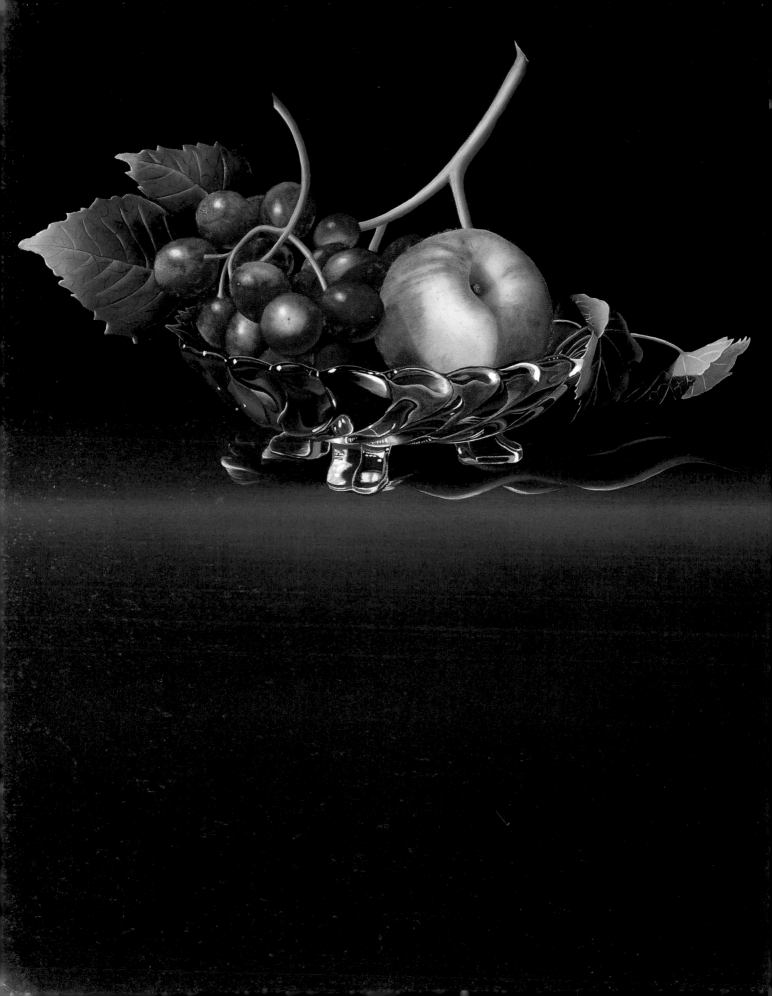

Contents

PREFACE 8

INTRODUCTION 10

Chapter One: THE ESSENTIALS 14

Materials 16
Palette Organization 21
Support Preparation 30
Toning Layer 32
Background Possibilities 33
Using an Alkyd Medium 38
Linework 38
Cleaning Up Mistakes 39
Cleaning Brushes 39
Blending 40

Chapter Two: PREPARING THE STILL LIFE 42

Lighting the Set-Up 44
Photography 47
Color Notes 51

Chapter Three: DRAWING WITH ACCURACY 54

Basic Techniques 56
Linear Perspective 66
Fruit Compote Drawing 68

Chapter Four: LAYERING FOR LUMINOUS EFFECTS 74

Basic Underpainting and Glazing 76
Colored Underpainting 90
Clear and Bright Yellows 102
Transparent Under, Opaque Over 108

Chapter Five: INSPIRATIONAL PROJECTS 114

Alstromeria 116
Autumn Flame 122

Chapter Six: FINISHING TOUCHES 126

Varnishing 128
Framing 135

Chapter Seven: CLOSING THOUGHTS 136

Finding Your Creative Style 138

RESOURCES 143
SELECT BIBLIOGRAPHY 143

INDEX 144

opposite:
Summer's Jewels
**Oil on hardboard,
20 x 17 inches
Private Collection**

Preface

One of the motivations for writing this book was to reacquaint artists with the wonderful possibilities of oil paint. I am in love with oil paint because of the richness of color that can be achieved with it (as with no other medium), the sensual feel of it as I paint, and it is by far the easiest painting media with which to work. For several years I worked with acrylic paint, but found that I was always trying to make my paintings look like they were created using oil paints. I came to my senses one day and put away the bottle of pain relievers (they were necessary for the headaches I acquired while working with acrylics) and moved on to a lifelong love affair with oil paints. Some people say they love the smell of oil paints. The truth is, they don't really smell that great (not like roses or lilacs), but they remind those who have painted with them that they are indeed something very special with which to work.

Some artists and art students think that oil paints are hard to manipulate, that they smell bad and take too long to dry. Well, just like anything else, once you know how to work with them (which you can learn from this book) they are easy to master. I am very particular about how my studio smells and have found a way to handle them so that there is very little odor in the room. In this book, I present materials and techniques that will speed the drying time, usually to within twelve to forty-eight hours.

Many artists and students are intimidated by oil paints because they were, after all, the choice of many great Old Master painters, such as Leonardo da Vinci, Raphael, Titian, and Rembrandt van Rijn. And most artists don't think they could ever paint as well as the Masters. The truth is, most of us will never, but we will have a lot better chance of achieving our goals if we use the same luscious paint as they did. They were all *very* smart and chose the very best medium with which to work. Leonardo da Vinci developed and tried many other media, but always returned to using oil paints. Acrylics weren't yet available and watercolor and pastel were considered to be appropriate only for sketching, but I think that even if those media had been available and in wider acceptance, the Master artists would have chosen oil paints anyway, just as I have and for the same reasons.

Nature's Magic
Oil on hardboard, 23 x 14 inches
Private Collection

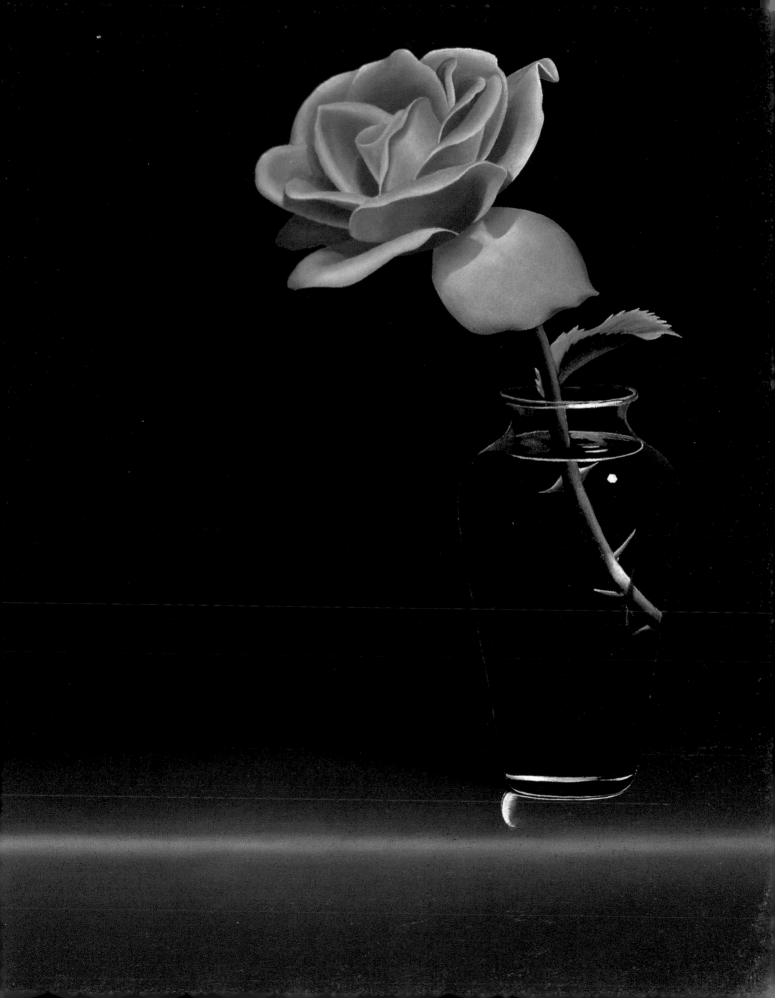

Introduction

Several years ago a painting at the Denver Art Museum absolutely took my breath away. It was *Bouquet of Flowers in a Vase* by Maria van Oosterwyck (1630-1693). Van Oosterwyck was a Dutch flower painter who made some of the most breathtaking paintings of that tradition. One of the qualities that really appealed to me was the luminosity of the paint—it glowed with an inner light. For quite some time after that I wondered, "How can I achieve that quality in my paintings?" I did some research into the techniques of the Dutch Masters and found that many of them used an underpainting and glazing technique. With this technique, the flowers (or other objects) are first painted using either a neutral color such as brown mixed with white or they are underpainted with a color that complements the subject. Transparent glazes of paint are then layered over the underpainting. The result is that light travels through the transparent layers of paint, reflects off of the white in the underpainting, and then travels back through the layers of glaze, giving the colors a luminous glow.

Soon after, I saw a landscape in a gallery that equally captivated me. A friend in the gallery told me to watch the painting as she dimmed the lights—the effect was magical. The more the lights were dimmed, the more the painting glowed. I was awestruck. My friend explained that the luminosity was the result of the artist's painting technique—a layering technique referred to as "underpainting and glazing." There it was again!

I started experimenting with this technique on some small paintings and found that I was especially excited to get to my studio on the days when I would be glazing. It was (and still is) like painting with stained glass. I have been working in this manner for several years now and it still seems just as magical as when I first started.

While Van Oosterwyck and other Dutch Master painters made incredible use of the materials available to them, today we have a vast array of products and colors from which to choose. Since the nineteenth century, many new colors have been developed that have a crystalline clarity that artists of the past could only dream about. Since many of these paint colors are transparent, they are perfect for using with the underpainting and glazing technique. There are other painting materials discussed in this book that while similar, are safer and easier to work with than those that the Masters used.

Illustration 1

Light

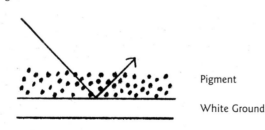

Pigment

White Ground

When we look at paintings created using the underpainting and glazing technique, we see light that has passed *through* color, sort of like looking through stained glass. So the flowers or other objects appear to glow with an inner light. This quality is referred to as "luminosity."

Illustration 2

Light

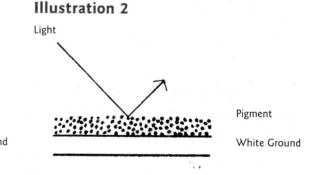

Pigment

White Ground

Opaque color reflects the light, so we see light that has reflected *off* of the color. The opaque color does not have the luminosity of transparent color.

opposite:
**Maria von Oosterwyck (Dutch, 1630-93),
Bouquet of Flowers in a Vase, ca. 1670s.
Oil on canvas, 29¹/₂ x 22¹/₂ inches.
Denver Art Museum 1997.219**

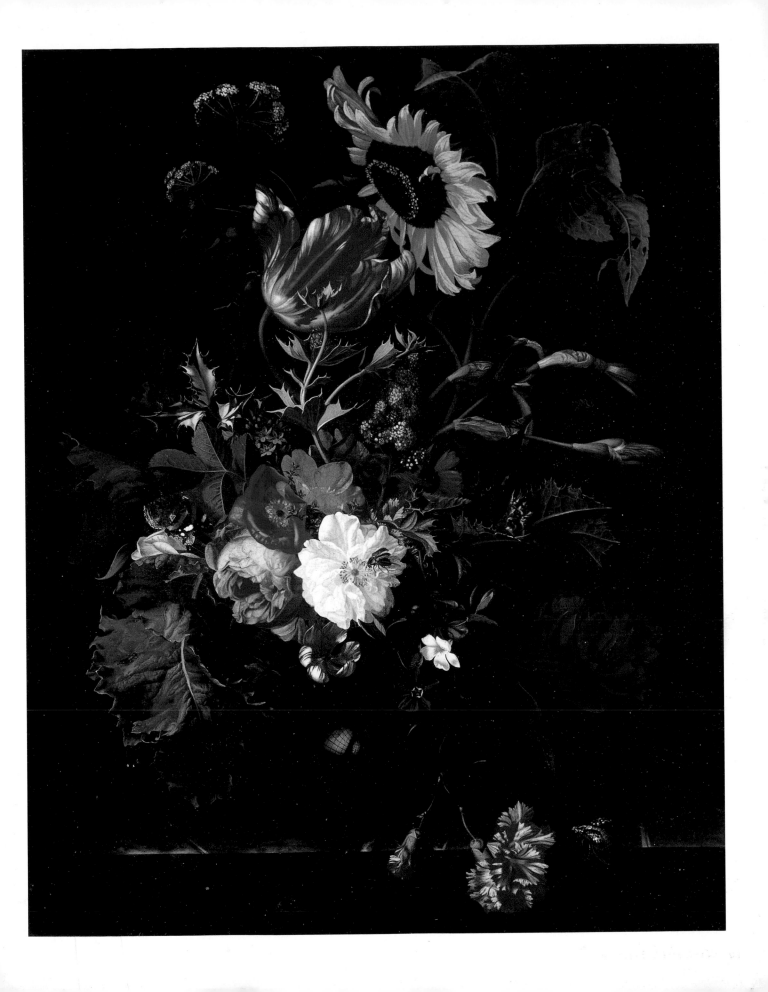

Another tool that we have today that was not widely available to the Dutch Masters is the camera. While some artists such as Jan Vermeer (Dutch, 1632-1675) used the camera obscura, an early optical device, to project images of sunlit objects onto the canvas, most painters relied on drawings and preparatory paintings. Artists would sketch various flowers, fruits, and leaves in different positions and stages of growth and decomposition. Paintings would then be composed using these drawings and paintings, ultimately creating an image of assorted flowers that could not possibly bloom simultaneously.

While artists in the past maintained their own gardens to use as subject matter, artists today can choose from the vast array of flowers available at florist shops and garden centers. Still, the satisfaction of painting flowers that are homegrown is enormous, and I would encourage flower painters to discover the possibilities of growing their own blossoms.

Some Old Master artists maintained their own collection of small creatures, such as insects, snails, butterflies, caterpillars, snakes, and lizards, which they would include in their paintings, either simply for interest or for their symbolic content. In fact, many of the flowers had symbolic meanings as well, meanings that were readily understood by art patrons of the day. In van Oosterwyck's painting, the sunflower represents the face of God, the tulip refers to the vanities of life, there are two insects mating that symbolize reproduction, flies that represent death and decay, and a butterfly that symbolizes the Resurrection. So all together the symbolic content is a spiritual celebration of the circle of life.

While many artists, including van Oosterwyck, chose to paint insect damage and the withering effects of time as a reminder of the temporal nature of life, others, like Rachel Ruysch (Dutch, 1664-1750), painted their subjects to be as perfect as possible, improving upon what nature could not. Accurately depicting the beauty of nature was more important to Ruysch than symbolism. Her father was a professor who taught anatomy and botany and maintained a large collection of scientific specimens, such as shells, skeletons, and rare fossils. Her father's influence shows up in the scientific accuracy of Ruysch's work, yet "she conveys her own passionate concern with the variety and beauty of nature, and hence of divine creativity." (Harris, Ann Sutherland and Linda Nochlin, *Women Artists: 1550 – 1950*. Alfred A. Knopf, 1977.) It is important to note that her paintings are not only scientifically correct, but they are also beautifully and elegantly so.

Ruysch was thirty-four years younger than van Oosterwyck and her work shows a progression towards a more dynamic compositional arrangement. In *Flower Still Life* (opposite), there is a diagonal line extending from the lower left corner to the upper right that is countered by the diagonal line of the table edge on the right. These diagonals create the impression that the flowers are still moving and growing, giving the painting a wonderful sense of life. This movement has the potential to create chaos, but instead the image remains cohesive because of the limited palette of reds and greens. It was said that Ruysch was "a supreme artist as well as a supreme painter, as great in her line as Rembrandt van Rijn in his." A grand complement, indeed, for anyone.

I have always loved the intimate world of still lifes, and painting them makes me feel connected to something greater than myself. I am amazed by the generosity of the earth and by the vast creative potential that it holds. My paintings are my way of honoring not only the gifts of the earth, but also those gifts of the Divine Creator. I encourage you to find what your special interests are and weave those into your paintings. It will enhance your artistic passion and breathe meaning into your work.

opposite: **Rachel Ruysch (Dutch, 1664-1750),** *Flower Still Life,* **after 1700. Oil on canvas, 29³/₄ x 23⁷/₈ inches. Toledo Museum of Art, Purchased with fund from the Libbey Endowment, Gift of Edward Drummond Libbey, 1956.57**

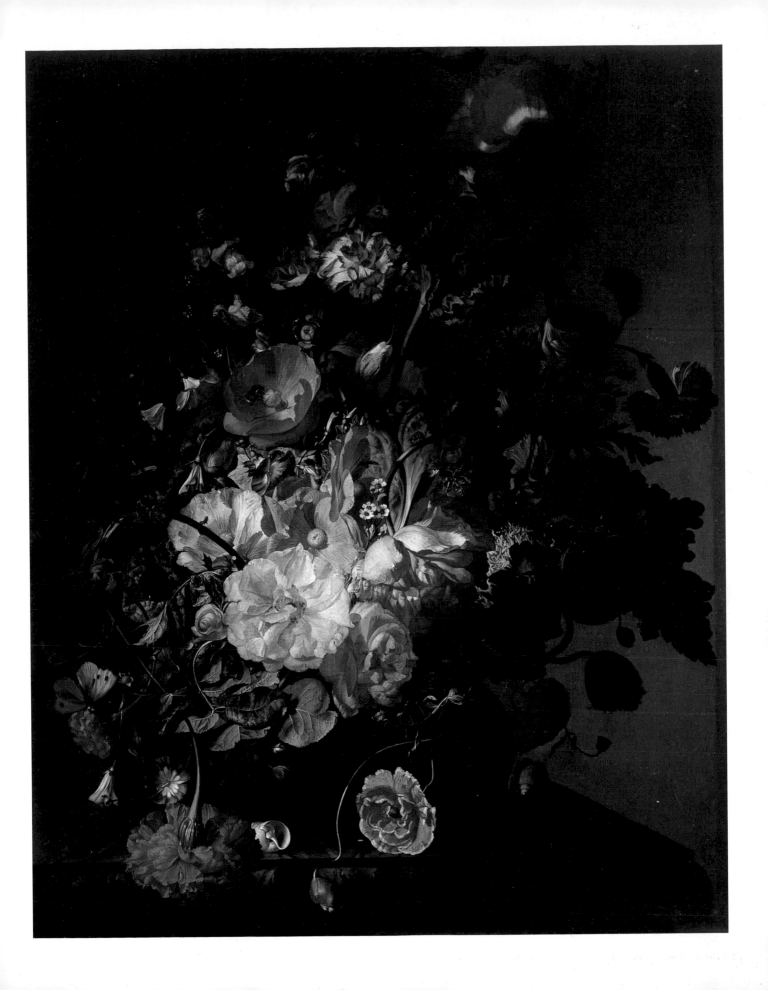

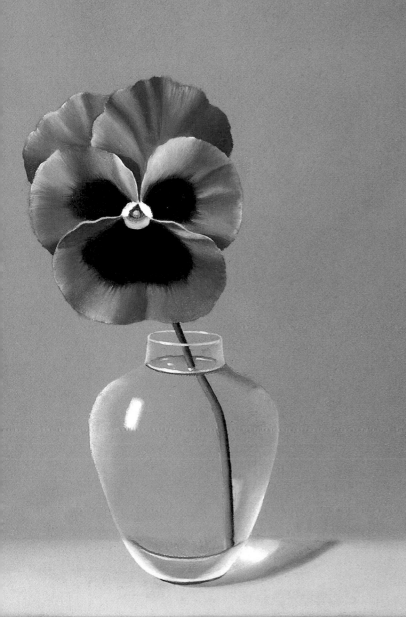

CHAPTER ONE

The Essentials

Sassy Faces
Oil on hardboard, 13 x 20 inches
Private Collection

I love painting pansies, especially in the winter-time when it is dull and gray outside. Pansies are some of the first flowers to peek through the snow in the early spring, which makes them very determined, courageous, and admirable. To capture their subtle and almost iridescent colors, I make lots of Color Notes and use the underpainting and glazing technique to imitate the color qualities.

Materials

I try to keep my materials as simple as possible, although I admit to having a weakness when it comes to oil paint colors. While it is not necessary to have as many tubes of paint as I do, having a wide selection is convenient and fun. The basic materials needed are:

Palette

I prefer 12 x 16-inch white palette pads with disposable sheets. I keep palettes with mixed colors in my freezer so the paint will remain soft and usable for the period of time it takes to make a painting. If I make mixes that I am particularly happy with, I let the paint on the palette dry out and then store the sheets in a stack for future reference. There are other palette options, such as the traditional wooden palette, or a piece of glass laid on a solid background. I prefer the disposable palette sheets because they are the easiest to store.

Palette Seal

A palette seal is a plastic box with a snug-fitting, airtight lid that is made specifically for the 12 x 16-inch disposable palettes. I store my paint in the freezer and have kept paint soft and workable for months. Once the palette seal is removed from the freezer, you have to let it thaw a bit before opening. Wipe off any condensation before opening the box.

Palette Knives

Palette knives are used for mixing paint. They are available in both plastic and metal with a variety of trowels and lengths. I prefer stainless steel blades with bent necks. The angled blade makes it easier to hold the knife without touching the paint and the metal ones are much less likely to break than the plastic ones. I have knives in two sizes for working with smaller and larger amounts of paint, but you really only need one palette knife.

Paper Towels

Use soft paper towels with as little texture as possible to wipe paint off brushes as you are working and to clean brushes at the end of a painting session. The softer the towels, the less abrasive they are on paintbrushes.

Prepared Surface

Without an appropriately prepared ground, oil paint will crack and flake off of the surface of the painting. Therefore, ground preparation is very important. An incorrectly prepared surface will affect not only pigment adhesion, but also the permanence of the painting itself. For further information, please refer to the section Support Preparation on page 30.

Palette, palette seal, and palette knives.

HELPFUL HINT
Artist materials are expensive and it is tempting to purchase materials at a hardware store because they appear to be much more affordable. But you truly get what you pay for and artist-grade materials are manufactured to very high standards to precisely do their job. House paint is not a substitute for any of the materials mentioned.

Solvent

The solvent, medium, and varnish that I use to make a painting all come from the same manufacturer. Each company designs their products to be chemically compatible. So, their solvent is made specifically to work with their mediums and so on. Bear in mind that it is important to remove all of the medium from your paintbrushes, and the solvent best able to do that is one made by the same company. Likewise, for stability, it is a good safeguard to use varnish from the same manufacturer. When using the Gamblin Artists Colors Co. medium I use their solvent, called Gamsol, and when using a Winsor & Newton medium I use their solvent, called Sansodor. Both of these solvents are odorless (relative to turpentine and mineral spirits). While it is tempting to use a less costly solvent from a hardware store, artist-grade solvents are very pure, have much less odor, and are a lot safer to use than hardware store brands. If you use solvents sparingly, as suggested in this book, they should last for quite some time.

The most frequent objections to oil painting are the drying time and the strong odor or fumes. I agree that both can be annoying, and the strong odor can even be sickening. Almost anyone who has attended an art class will remember the smell of turpentine from open jars and cans sitting all over the studio. In addition to having an unpleasant odor, leaving around open jars of solvent just isn't safe! There are better ways to work that don't involve open solvents or varnishes.

When working, I pour only about an inch and a half of odorless solvent in a cleaned-out artichoke heart jar. The only time I open the small jar is when I am cleaning my brushes or wiping out a mistake with a small amount of solvent on my brush. This way, if I accidentally spill the solvent, it's not going to be too much of a mess to clean up. Using only a small amount of solvent at a time is also cost-effective. When the solvent is muddy, I let the pigment settle and then pour the clear solvent into a new jar. I screw the cap back on the old jar, set it on a shelf in the garage, and when I have half a dozen or so I take them to a waste disposal site. Never pour solvent down the drain! It is difficult to remove from the water system and can be quite polluting.

Brush Cleaning Pad

A brush cleaning pad is a small round sponge with short fibers sticking out of the top of it that I place in the bottom of my solvent jar. The pad is soft enough to safely rub the brushes on, yet stiff enough to knock the pigment and medium out of the brush. Stroke brushes across the soft, short fibers of the cleaning pad to remove paint residue. Residues get trapped at the bottom of the jar, keeping the solvent cleaner longer. Once the solvent gets muddy, I pour off the clear solvent, as mentioned above, and leave the dirty brush pad in the jar to dispose of along with the old solvent. Instead of using an old artichoke heart jar, small glass jars with pads for cleaning paintbrushes can be purchased as a set at art supply stores.

CAUTION
Many oil paint mediums are toxic and flammable. Be sure to follow all appropriate safety precautions when working with and storing these materials.

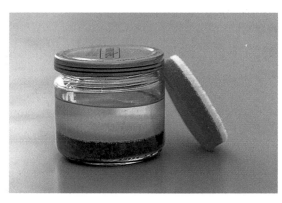

Solvent and brush cleaning pad in an artichoke heart jar.

Murphy's Oil Soap

After I have cleaned my brushes as much as possible in the odorless solvent, I wash the solvent out with Murphy's Oil Soap. Murphy's is a household cleaner and can be found anywhere that sells everyday cleaning products. I work some soap into my brush, and then rinse it out. I then continue soaping and rinsing the brush until the water runs clear. It's not so much of an issue with small brushes, but larger brushes can hold quite a lot of solvent. I always wash out even the small mop brushes because it is important for them to be fluffy.

Murphy's Oil Soap is also useful for removing dried paint or dried paint and alkyd medium from brushes. I work some of the soap into the brush, wrap the brush in aluminum foil and a plastic bag for twenty-four hours, and then rinse it out. Sometimes this has to be repeated a second or third time, but it always works.

Alkyd Medium

I use alkyd mediums for all layers of the painting process. They reduce the drying time of oil paint and can be used to thin a paint to create a transparent glaze. The alkyd medium from Winsor & Newton is Liquin and the alkyd mediums from Gamblin are Galkyd and Galkyd Lite. Galkyd has a slightly thicker consistency and faster drying time than Galkyd Lite.

Single-edge Razor Blade

Single-edge razor blades are useful for trimming the odd stray hair out of a brush. Occasionally, I use a razor blade to cut a new edge on a sable brush that has become worn. For this you need a fairly new and very sharp blade. Lay the brush on the cardboard back of a palette pad and hold it very firmly with one hand while quickly cutting off the worn hairs with the other. Be sure that your cut is not at an angle.

Wipe-Out Tool

Wipe-Out Tools are great for "erasing" mistakes in paint and for smoothing ragged lines. A Wipe-Out Tool has two rubber tips; one tip has a fine point and the other is beveled. The pointed tip is good for removing thin lines or very small areas of paint. The beveled tip is better for wiping out large areas of paint.

A Wipe-Out Tool.

HELPFUL HINT

Tweezers are useful for pulling small hairs out of wet paint. Stray hairs can come from your brush or even from your hair and they will find their way into wet paint. If the hair is completely embedded in the paint, tease an end of it up so you can grasp it with the tweezers and pull it out. If you disturb the surface of the paint, it can easily be smoothed with a small mop brush.

Brushes

I use a wide assortment of brush types and sizes. Most of the time I choose flat brushes in sizes that are appropriate to the areas to be painted. I use flat brushes to fill in color as well as to blend it. I use large synthetic brushes to paint large background areas and smaller synthetic or sable brushes for smaller areas. Sable brushes hold more paint than synthetic ones, and are rigid enough to withstand the pressure necessary to apply oil paint. A synthetic brush will do an adequate job, but it won't last nearly as long as a good sable brush.

I prefer sable brushes for glazing. They are softer in texture than synthetic ones, making it easier to lay down an even layer of glaze. But, for smaller flat brushes, such as sizes 0, 2, and 4, I prefer synthetic over sable. The synthetic hairs tend to hold their chisel edge (the side edge) more crisply, making it easier to do precision work.

I use small round synthetic brushes for linework and fine detailing. I use sizes 2, 1, 0, 00, 2/0, 6/0, 10/0, and 18/0 (the larger the number in front of the 0, the smaller the brush

is). For blending in very small areas, I sometimes flatten a number 2 round and use it as I would a flat brush. I usually have more than one of each brush size as the hairs are prone to bloom, or fray and curl at the ends. As soon as a brush loses its tip, I throw it out.

Paintbrush handles are long so artists can stand away from their paintings while working on them. I tend to work up close to the painting surface so I find long handles unwieldy. If a small-size brush has a long handle, I will saw the handle to a suitable length and then sand the end until it is smooth. Mop brushes are useful for eliminating brush marks. They are round, fluffy brushes and come in sizes from $\frac{1}{4}$ inch to 1 inch. Buy the best brushes you can afford. If you treat them well, they will last for a long while.

Brushes should be stored so that the brush is not resting or leaning on the hairs. Placing them handle end down in a jar or wide mouth bottle works well. I have mine standing in terra-cotta pots that are filled with dried beans so the brushes don't move around. And I have them grouped by size and kind in several pots so they are easy to find.

An assortment of flat and small round brushes.

Mop brushes in assorted sizes.

Oil Paints

The colors that were used for each of the painting demonstrations are the ones that I like to use, but there are many other colors available from a variety of oil paint manufacturers. While the same color name in different brands is not necessarily the same color, they are usually at least a bit similar.

Some colors are inherently expensive and others are not. Cadmiums and cobalts, for example, are always expensive, while earth colors such as the siennas and umbers are usually inexpensive. Just remember that you get what you pay for: when you pay less for a tube of paint, you are probably getting less pigment and more oil. It is often a better investment to buy a high-quality oil paint. A little bit of a high-quality color will go a long way.

All paint manufacturers have color charts available. If you want to know what a color is going to look like, ask to see a color chart. There will also be notations on the chart as to whether a color is opaque, transparent, or somewhere in between. For glazing, it is best to start with a transparent color. A more opaque color can be made into a glaze by mixing it with medium, but the glaze will not be as transparent as one that starts out that way.

For underpainting, I use Underpainting White from Winsor & Newton and Flake White Replacement from Gamblin Artists Colors Co. They are milled to create a surface that is just a little bit rougher than Titanium White. That tooth also makes the surface less glossy and less slippery, which makes the glaze layers easier to control. These paints create a very opaque layer and it will feel as if you are painting with velvet. The advantage that these two whites have over some others is that they do not have lead in them, so they are less toxic and therefore safer to use. They also dry more quickly than Titanium White. But it is fine to use Titanium White for underpainting.

For the final highlights in a painting I use Titanium White. It is more opaque than the underpainting whites and can create an extra sparkle of light in the final layer of a painting. All three of the whites that I have mentioned are fine to use throughout a painting, and it is really only necessary to have one of them. My choice would be Titanium White, as it is the most versatile of the whites.

These are my transparent oil colors. They are all in their color families, so they are easy to find. And, as you can see, there are many different brands and LOTS of colors.

Palette Organization

While I use a lot of different colors, I have two basic palettes that I start with and then add to according to what I am painting. One palette uses mostly opaque colors and the other uses transparent colors. Unless otherwise noted, all colors are Winsor & Newton brand. Winsor & Newton is a really good quality of paint and, over the years, it has become my brand of habit. The colors for my basic palettes are listed below and on the next page. These basic colors are available in many other high-quality brands of paint, such as Gamblin, Grumbacher Pre-Test, Sennelier, and Daniel Smith brands. Be sure to use professional grades of paint rather than student grades.

Creativity is by its very nature somewhat free-flowing and chaotic. Wherever I can, I use organization to balance and add structure to that natural tendency. Knowing where my colors are on my palette and where the tubes are in my studio makes the creative process enjoyable rather than frustrating.

In my studio and on my palette I keep transparent colors separate from opaque colors. Then, I keep each color family together within their opaque or transparent group. The colors are organized in the same way as they appear on the color wheel, so that the yellows are together and next to the oranges, the oranges are next to the reds, and so on. I lay out the colors in their color wheel order regardless of how many I am using. (Sometimes I separate out the "earth" colors so they are all together.) This organization makes it quick and easy to find a particular color on my palette.

I use these basic palettes as a starting point when I begin a painting. The colors are personal choices based on theory, what I paint, how I want the finished painting to look, and my subjective perception of color. We all see color differently, so feel free to build upon these palettes to discover what colors work best for you. As you will see in the demonstrations, I own and use *a lot* of different colors. There are several reasons to have more than just the basic palette:

1. It's more convenient to squeeze paint out of a tube than to mix it yourself.
2. Every time you mix colors on a palette some of the intensity of each is lost. Sometimes mixing does not turn out to be exactly the same color as color theory says it will be.
3. The more tube colors you have, the more potential colors are available.

Basic Opaque Palette

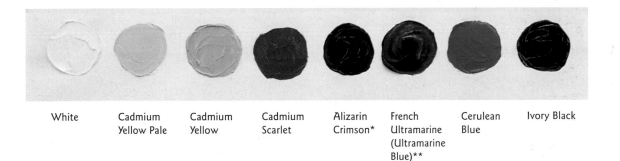

| White | Cadmium Yellow Pale | Cadmium Yellow | Cadmium Scarlet | Alizarin Crimson* | French Ultramarine (Ultramarine Blue)** | Cerulean Blue | Ivory Black |

*Even though Alizarin Crimson is a transparent color, I prefer it over the Cadmium Reds because of how nicely it mixes with the blues to make violets.
**Even though French Ultramarine, like the Alizarin Crimson, is transparent, I also like the way it mixes.

Basic Transparent Palette

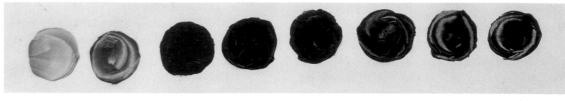

| Transparent Yellow | Indian Yellow | Gamblin Napthol Red (Yellow Shade) | Alizarin Crimson (or Gamblin Quinacridone Magenta) | French Ultramarine | Winsor Blue (Green Shade) | Grumbacher Thalo Green (Yellow Shade) | Sap Green |

Notice that in each palette there is a warm and cool version of each of the primary colors: yellow, red, and blue. The transparent palette has the addition of two greens. I use green often as it almost always has a role in fruit and flower compositions, and these greens are really convenient. There are an *endless* variety of colors that can be mixed from these basic palettes. There aren't any "earth" colors in either palette. I have them, and use them, but they can also be mixed from these colors.

Remember that theory is just that, *theory*, and the way individual paints mix with one another is not always what is expected. That is because of the chemistry of the paint. The tube colors are not only pigments, they are colored chemistry. So don't be put off when you don't get what you had every right to expect. Try to remember the result—there might come a time when *that color* is just exactly the one you need.

Color Basics
There are three qualities about every color: value, intensity, and temperature.

VALUE is the lightness or darkness of a color in relation to another color. Red is light relative to violet; however, red is dark relative to yellow. In general, light colors advance while dark colors recede. Add white to lighten the value of a color, and black to darken the value. But keep in mind that you will be changing the color's intensity.

INTENSITY is the brightness or dullness of a color in relation to another color. A yellow daffodil is bright relative to peanut butter, but peanut butter is bright relative to coffee grounds. In general, bright colors advance while dull colors recede. The intensity of a color can be reduced by adding white, black, a complementary color, or an earth color from the same family. Sometimes, when I darken a color I also dull it with a complementary color. Conversely, when I lighten a color with white I may also add a little bit of a yellow to make it advance a little bit more.

TEMPERATURE is the warmness or coolness of a color in relation to another color. A warm color generally has more yellow and a cool color generally has more blue. A yellow daffodil is warmer than an orange poppy, but the orange poppy is warmer than a blue sky. In general, warm colors advance while cool colors recede.

By combining all three of these qualities you can effectively give your paintings a sense of form or depth.

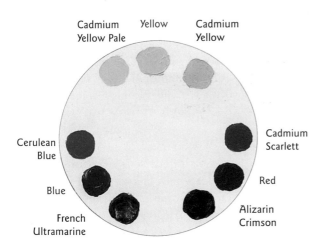

Cadmium
Yellow Pale Yellow Cadmium
 Yellow

Cerulean
Blue

Cadmium
Scarlett

Blue Red

French Alizarin
Ultramarine Crimson

Color Wheel with Opaque Mixed Primary Colors

Having a warm and cool of each of the primary colors will give you more potential colors than if only one of each were used. And, a color very close to the full intensity primary color can be created combining the warm and cool colors.

Color Wheel with Transparent Mixed Primary Colors

These are the transparent primary colors created by mixing a warm and cool of each. The "red" is the least intense of the mixed primary colors. The yellow in the Napthol Red (Yellow Shade) mixes with the blue in the Alizarin Crimson, creating some green in the red and making the "red" a little bit dull. I use Gamblin Napthol Red (Yellow Shade) and Alizarin Crimson because they mix so well with the other colors on the color wheel. If I need a full intensity red, I use a tube color.

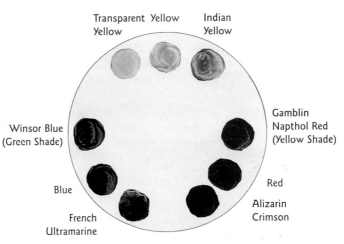

Transparent Yellow Indian
Yellow Yellow

Winsor Blue Gamblin
(Green Shade) Napthol Red
 (Yellow Shade)

Blue Red

French Alizarin
Ultramarine Crimson

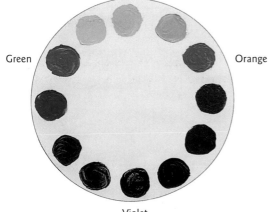

Green Orange

Violet

Color Wheel with Secondary Colors Added

Secondary colors are created by mixing two primary colors together. Yellow and red mixed together create orange; yellow and blue mixed together create green; and red and blue mixed together create violet.

Oranges

Yellows and reds are mixed together to create a variety of orange colors.

Greens

Yellows and blues mix together to create warm and cool versions of green. None of these greens is a full intensity color, but most of the time they work well for my color choices. Mostly, I use greens for stems and leaves, so they are not usually the most important part of my painting and I don't want them to be full intensity. If I need a brighter green I use a tube color.

Violets

Reds and blues mix together to create warm and cool varieties of violet. None of these violets is a full intensity color. They are beautiful colors and I use them, especially mixed with white to make them very light. (I did add white to all four examples to make the color more visible.) If I need a brighter violet, I use a tube color.

HELPFUL HINT
The most intense colors result from mixing colors that are closest to each other on the color wheel, such as Cadmium Yellow and Cadmium Scarlett. Use colors that are farther apart on the color wheel, such as Cadmium Yellow and Cerulean Blue or Cadmium Yellow and French Ultramarine, to mix less intense or duller colors.

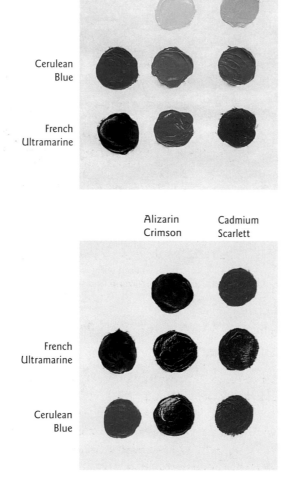

Color Wheel with Tertiary Colors

Tertiary colors are the colors on either side of a secondary color, such as yellow-green and blue-green, or red-orange and red-violet. The same tube colors were used as for the secondary colors. Each of these colors can be mixed with its complement, or near complement to create more or completely neutral colors.

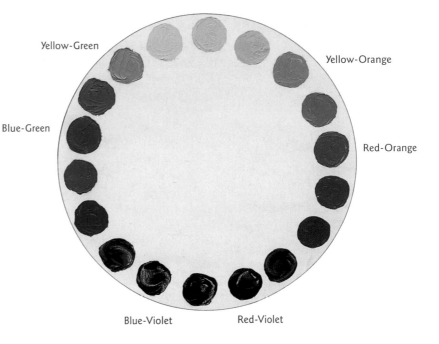

Yellow-Green

Yellow-Orange

Blue-Green

Red-Orange

Blue-Violet

Red-Violet

Mother Color Mixing

Mother Color

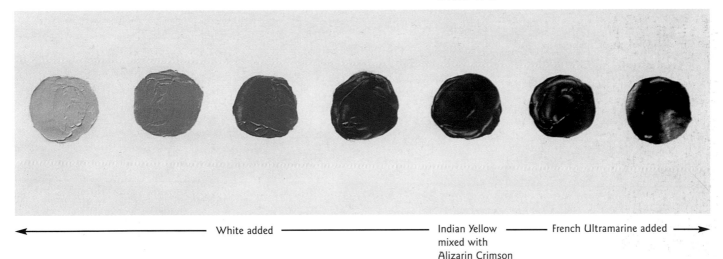

◄——————— White added ——————— | Indian Yellow mixed with Alizarin Crimson | ——— French Ultramarine added ——►

"Mother Color" is not a common technical term. I know I didn't come up with it and I don't remember where it came from, but I have found it to be quite useful. The Mother Color is the one from which all other colors of a series are mixed. For an underpainting, the Mother Color is the one to which white will be added. Often the Mother Color is mixed using transparent colors so that it can be used as a glaze on top of the underpainting.

I mixed Indian Yellow with Alizarin Crimson to get a transparent orange. Then I added white to it four times to lighten. To darken, I added French Ultramarine to the Mother Color twice. The darkest color wanted to turn green, so I added a little bit more Alizarin Crimson to the mix.

Complementary Color Mixing

Complements are colors that are across from each other on the color wheel, such as red and green, orange and blue, and yellow and violet. Mixing a color with its complement is a wonderful way to lower its intensity. A complement can be used to dull a color just a little bit, or to dull it to the point where it is neutralized and neither of the complements can be identified. These neutral colors are very beautiful and useful.

In the examples shown, the complementary colors were mixed together to reduce the intensity of each one. The middle color is the neutral color; a color in which neither of the two colors can be identified. Then white was added to the neutral color twice. The neutral colors created this way are far livelier than the browns that can be squeezed out of tubes. These mixed browns can also be shifted slightly in any direction to create warmer or cooler colors. Using neutrals such as these can be very effective in a painting where subtle color changes are desired.

Any color with a yellow in it mixed with a color with a blue in it will have a tendency to turn green. The way to correct this is to add some of the red that is in one of the two colors. When I was mixing the orange–blue complements the colors were turning green, so I added a very small amount of Cadmium Scarlet to the mixes to neutralize the green. And when mixing the yellow–violet complementary colors I added Alizarin Crimson to the mixes.

Think of a color in terms of its *color-ness;* like *red-ness* or *violet-ness*. So rather than thinking of complements as being exactly opposite each other on the color wheel, consider mixing colors from families that are opposite each other on the color wheel, like *a* red with *a* green. Mixing colors that are near complements creates a whole world of beautiful and unexpected colors.

Red–Green Complementary Mixing*

Red Neutral Green

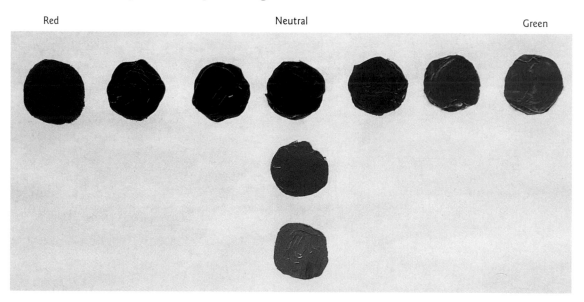

The red and green were made by mixing a warm and cool of each color.

Orange–Blue Complementary Mixing*

Orange Neutral Blue

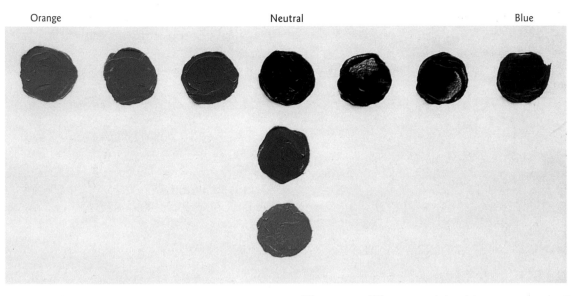

*The orange and blue were made by mixing a warm and cool of each color.

Yellow–Violet Complementary Mixing*

Yellow Neutral Violet

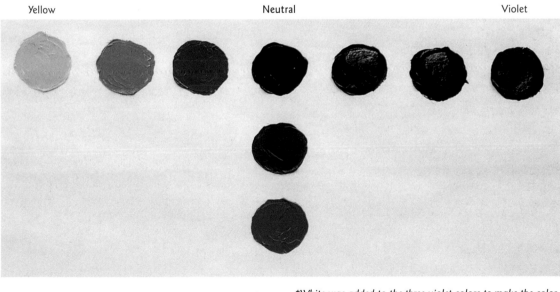

*White was added to the three violet colors to make the color more visible.
*The yellow and violet were made by mixing a warm and cool of each color.

Color Chart of Transparent
Reds Mixed with White

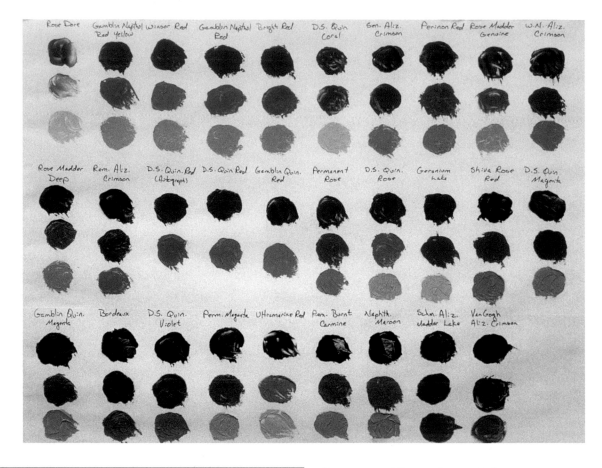

COLOR PALETTE

Rose Dore

Gamblin Napthol
Red Yellow

Winsor Red

Gamblin Napthol Red

Bright Red

Daniel Smith
Quinacridone Coral

Sennnelier Alizarin
Crimson

Gamblin Perinone Red

Rose Madder Genuine

Winsor Newton
Alizarin Crimson

Rose Madder Deep

Rembrandt Alizarin
Crimson

Daniel Smith
Quinacridone
(Autograph) Red

Daniel Smith
Quinacridone Red

Gamblin Quinacridone
Red

Permanent Rose

Daniel Smith
Quinacridone Rose

Geranium Lake

Shiva Rose Red

Daniel Smith
Quinacridone
Magenta

Gamblin Quinacridone
Magenta

Bordeaux

Daniel Smith
Quinacridone Violet

Permanent Magenta

Ultramarine Red

Rembrandt Burnt
Carmine

Daniel Smith
Naphthamide Maroon

Schmineke Alizarin
Madder Lake

Van Gogh Alizarin
Crimson

Getting to Know New Colors

I *love* buying and getting to know new colors. Whenever I buy a new color, I get to know it by mixing it with white and then mixing it with some of its complementary colors. Then, I mix it with whatever else seems like a good idea. I make swatches of those colors on palette paper and tape it to the wall in my studio until I am familiar with the new possibilities.

These are charts I made of my transparent reds, oranges, and yellows. I put down a sample of each color directly from the tube. I apply the color with some thickness to show what it would look like in several layers, and I have a part of the sample reveal what only one layer would look like. Then I mixed each one with two amounts of white.

Color Chart of Transparent Oranges and Yellows Mixed with White

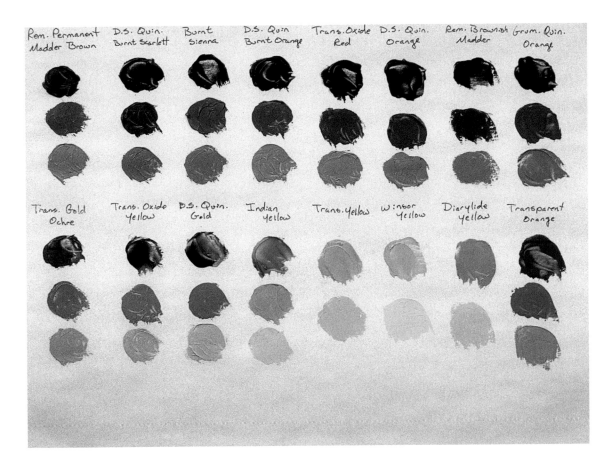

Rem. Permanent Madder Brown | D.S. Quin. Burnt Scarlett | Burnt Sienna | D.S. Quin. Burnt Orange | Trans. Oxide Red | D.S. Quin. Orange | Rem. Brownish Madder | Grum. Quin. Orange

Trans. Gold Ochre | Trans. Oxide Yellow | D.S. Quin. Gold | Indian Yellow | Trans. Yellow | Winsor Yellow | Diarylide Yellow | Transparent Orange

A NOTE ON ALIZARIN CRIMSON:

Alizarin Crimson is one of the least permanent colors available from paint manufacturers today. The only reason that it is available is because so many artists love the color and demand it. I would strongly suggest that—unless you are absolutely dedicated to using it—you use the color substitutes that manufacturers now offer. (I am in the process of changing over to Winsor & Newton Permanent Alizarin Crimson.)

COLOR PALETTE

Rembrandt Permanent Madder Brown

Daniel Smith Quinacridone Burnt Scarlett

Burnt Sienna

Daniel Smith Quinacridone Burnt Orange

Transparent Oxide Red

Daniel Smith Quinacridone Orange

Rembrandt Brownish Madder

Grumbacher Quinacridone Orange

Transparent Gold Ochre

Transparent Oxide Yellow

Daniel Smith Quinacridone Gold

Indian Yellow

Transparent Yellow

Winsor Yellow

Grumbacher Diarylide Yellow

Transparent Orange

Support Preparation

The SUPPORT is traditionally either canvas or wood panel. Canvas has the advantage of being lightweight and flexible, which facilitates rolling for shipping. However, there are disadvantages as well: Canvas requires more preparation time because it must be stretched over stretcher bars; and, because of the weave of the threads, canvas has hills and valleys. I prefer using 1/4-inch *untempered* hardboard panels (Masonite is a brand of hardboard). Be sure to purchase "untempered" rather than "tempered." Tempered hardboard has oils in it that make it unsuitable and unstable for preparation with gesso. It is smooth and has only to be cut to the appropriate dimensions and lightly sanded on the painting surface.

If canvas is used, whether cotton or linen, a layer of SIZE is necessary to seal the surface. When linseed oil (the most common oil in oil paint) comes into contact with canvas or wood it causes a degradation of the support. Traditionally, rabbit skin glue was used to seal a canvas support, but it can absorb and release moisture, causing the surface to be less stable. Today PVA (polyvinyl acetate) size is available from several artist material manufacturers. It is more stable and far easier to work with than its predecessor.

The next of the preparatory layers is the GROUND. This layer has to be receptive to oil paints. There are two choices: traditional or modern. The traditional ground is an oil-based primer. Again, several artist material manufacturers make great products. The oil- or alkyd resin-based grounds are usually densely pig-

mented and so only two layers should be applied. The oil-based grounds need to dry for six months, while the alkyd resin-based grounds are ready to receive paint as soon as they are dry to the touch.

The modern ground is an acrylic gesso, which can be applied to canvas or linen. (I always use Liquitex gesso, but there are many fine brands available.) If you choose to use an acrylic gesso ground, the canvas will not need a layer of size. If you are using hardboard, the surface of the board should be sanded to open it up and make it more receptive to the gesso.

The gesso can be applied with either a brush or a dense sponge roller. If you brush-on gesso, the surface texture will be much the same as that of the canvas. Rolling on the gesso will create a smoother surface for painting. I prefer to apply the gesso with a dense sponge roller. These can be purchased at both art supply and hardware stores. First I dampen the roller and squeeze out as much of the water as possible. This prevents the sponge from drying out between layers. Then I pour some of the acrylic gesso onto a disposable paper palette and roll the roller through it until the sponge is covered with an even but not heavy coat of gesso.

Next, I roll the gesso onto a section of my sanded board until the sponge is empty. I keep rolling over that section while it dries. The drier the gesso becomes, the less "tooth," or texture, it has. I like a painting surface that is as smooth as possible; however, there has to be some tooth or texture to the surface for it to

HELPFUL HINT

If you are using 1/4-inch untempered hardboard, to prevent the board from bowing, whatever preparation is used on the painting surface should also be used on the back.

drag the paint off of the brush. If the surface is too smooth, the paint will just slide, or "skate," over it; the paint will be very difficult to handle and the bond between the gesso and the paint layer will be unstable.

Let the first layer of gesso dry before applying the next (acrylic gesso is dry when it no longer feels cold to the touch). Apply four or five layers, lightly sanding between the layers for better adhesion. Whether you are using a brush or roller, it is important to apply successive layers at right angles to each other. I let the layers of acrylic gesso dry and harden for a day, and then very lightly smooth the surface to even it out and to take off any areas that are too coarse. I use a piece of my linen finish

stationery to smooth the surface, but a piece of brown wrapping paper or brown paper bag would also work. No matter what you use, be careful not to smooth the surface too much.

There are some disadvantages to using an acrylic ground. The bond between the acrylic gesso and the oil paint is a physical bond (which is why it must have some tooth), while the bond between an oil or alkyd resin ground and oil paint is a chemical one. A chemical bond is more stable than a physical bond. Acrylic is also more flexible than oil, which increases the likelihood of cracking and flaking between the layers. Applying the layers of acrylic gesso in opposite directions can compensate for this.

Roll the gesso over a section of your sanded board until the gesso is no longer moving off of the roller or on the board.

Toning Layer

Traditionally the toning layer was called the *imprimatura*, which literally means "what goes before first." The toning layer is a transparent layer of paint mixed with medium that is applied over the gesso or ground. There are several advantages to using a toning layer:

1. It is a great surface on which to paint because it has good tooth for the subsequent layers. It also eliminates the intimidation of a blank, pristine white surface.
2. It is usually of a medium value so it presents a better surface than the bright white of the gesso or ground from which to judge the values of the underpainting.
3. The background layer can be more or less transparent depending upon how much of the toning layer you want to show through.
4. If the background has some areas that are less opaque than others, the color of the toning layer is more interesting showing through than the white gesso or ground.

I apply the toning layer with a White China Bristle Brush. Since these brushes are very inexpensive, they can be discarded once the toning layer is complete (this will not only reduce work time, but will also reduce the amount of brush cleaner you use). I am always concerned with drying time, because the sooner a painting is dry, the less airborne dust and particles can get into it and the less likely it is to be harmed. So when I brush on the toning layer, I always mix the paint with alkyd medium and solvent (to thin it even further). The alkyd medium not only helps make the paint more fluid and easier to apply, it also accelerates the drying time. And, as I will be using the alkyd medium in the glazing layers, I always include it in the toning layer to build a stable painting.

Apply the toning layer so that all of your brush strokes go in one direction. Brush the paint out as smoothly as possible and leave a soft leading edge to blend into subsequent strokes. I prefer that the brush strokes not show at all, so after I have covered the surface working in one direction, I brush in the opposite direction to eliminate any ridges. Be sure to pick out any stray bristles left behind by the brush.

Background Possibilities

One of the things that every artist has to do in their studio is keep themselves entertained. I was getting bored with the background colors that I was using and wanted to find a way to make them more interesting, so I started experimenting with layering the colors. Since all oil colors are to some extent transparent, a color can be "influenced" by the color of the layer or layers beneath it.

I started adjusting the color of the toning layer in an effort to influence the background color. So, if I wanted my background color to be a little bit violet, I made the toning layer violet and painted a fairly neutral gray over it. If I wanted a gray background with a slightly blue cast, I made my toning layer French Ultramarine or French Ultramarine mixed with

Ivory Black, and then layered over it with gray. Likewise, to add warmth to a cool gray background I used a Raw Sienna toning layer. The toning layer can be a very bright color, like a Thalo Blue or Green, or a very muted color, like Raw Umber. (Note: Examples of a green toning layer with an opaque color painted over it is in the demonstrations of *Garden Rainbow*, page 101, and *Summer Magic,* page 113.)

The background color that is painted over the toning layer can be opaque or transparent. If it is opaque, then the layer can be painted completely opaque or more medium can be used in some areas (or all over) for greater transparency. Areas can also be gently wiped out with a brush or soft, lint-free cloth to reveal more of the toning layer color.

A toning layer of French Ultramarine mixed with alkyd medium was used.

A toning layer of Raw Sienna mixed with alkyd medium was used.

A mixture of gray was used over the French Ultramarine toning layer. The opaque color was wiped off in some areas with a large flat brush, then I used a large, soft mop brush to blend the transitions.

Here, a layer of gray was painted thinly over the toning layer, allowing the Raw Sienna to glow through. The gray is cool, looking a bit blue, and there is a shimmer between the warm Sienna and gray colors.

A transparent background can be created as well. For these I use many layers of a color or alternating colors to create deep, rich darks. In the following example, several layers of French Ultramarine were applied to create a dark blue. Bear in mind that, because French Ultramarine is not a very dark value, it will take many layers to achieve this effect.

French Ultramarine mixed with Liquin (medium) was used for the first layer.

The fourth layer of French Ultramarine mixed with Liquin.

In the following example, layers of Grumbacher Thalo Green (Yellow Shade) mixed with Liquin create a beautiful green background. Although this color is quite intense, when several layers of it are used the resulting shade is very dark and not so overpowering. (Winsor & Newton and Gamblin Artists Oil Colors Co., as well as other fine companies, make good examples of this green as well.)

Grumbacher Thalo Green (Yellow Shade) mixed with alkyd medium was used for the first layer of the background.

The third layer of Thalo Green (Yellow Shade) mixed with Liquin.

Here, Winsor Violet (Dioxazine Purple) was used for the first layer. When several layers of this color are used it creates a very dark violet that is only barely distinguishable from black, but in the proper lighting it has warmth that black does not possess.

Winsor Violet (Dioxazine Purple) was used for the first layer.

The third layer of Winsor Violet mixed with alkyd medium.

Different colors can be layered to create an intriguing blend. In this example, I wanted to create a transparent dark violet background, so I alternated layers of transparent blue and transparent red. This causes the colors to mix optically (rather than chemically), creating a more visually exciting color.

In this example, French Ultramarine was used for the first layer. For the second layer, I used Gamblin Quinacridone Magenta. I chose it because it is a cool red and is of almost equal value and intensity as the French Ultramarine. I could make the result darker by painting another layer of French Ultramarine and then Magenta.

For this background sample, I used the same colors as in the previous sample, but changed the order in which I layered them. You can see that the sequence of the layering does matter. The violet that results from this sequence leans more to the red, while the sample where the French Ultramarine was used for the first layer is more blue.

The toning or "influence" layer doesn't have to be all one color. This toning layer has areas of Indian Yellow, Gamblin Napthol Red (Yellow Shade), Permanent Alizarin Crimson, and Sap Green. This is the influence layer for Autumn Flame, on page 125.

In this example, the opaque background planned for the finished painting was to be graded from light gray in the upper right to dark gray in the lower left. I decided to accentuate that change with a temperature shift in the toning layer from red-violet to blue-violet.

Here, Alizarin Crimson is mixed with Grumbacher Thalo Green (Yellow Shade) to make a rich, deep black. It is a transparent black that when used in several layers has depth that a more opaque black, like Mars Black or Ivory Black, just cannot match. (A great black can also be achieved by layering Alizarin Crimson and Thalo Green.) One or two more layers of the black mixture will not change the value of the color, but will give it more depth.

These are just some examples of what can be done with layering. The possibilities with this layering technique are limitless. If a background turns out badly it is early enough in the painting process that you can just start over. You might even have a better idea of how to achieve the desired results the second time around.

When I finish painting the background, I always store the excess paint in a palette seal in my freezer. The frozen paint remains usable for several weeks (sometimes even months)—long enough to provide me with the *exact* colors needed to touch up the background or to paint clear glass.

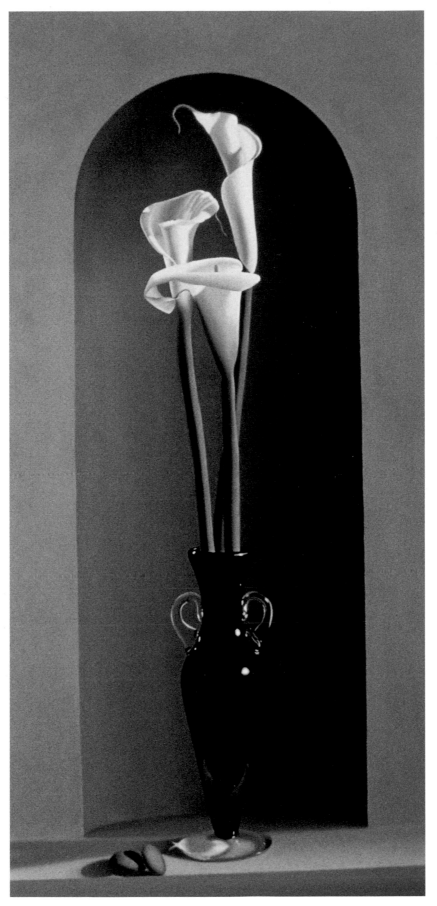

For the influence layer of *Harmony*, I used really bright colors: Transparent Red, a Transparent Orange, and Purple Madder mixed with Ultramarine Blue. Then, when I painted the dull green on top of it, I left small areas where the color underneath showed through. That made it more interesting for me to paint and for viewers to see.

Harmony
**Oil on hardboard,
55 x 24 inches
Collection of Jane
and Ron Gother**

Using an Alkyd Medium

To create a stable painting using alkyd mediums, alkyd mediums *must* be used in *all* of the layers of the painting, even if only just a whisper amount. Using alkyd medium in the lower layers of the painting but not in the top layers will result in a slower drying layer on top of a faster drying one, which can lead to paint cracking and peeling.

Traditional mediums used in oil painting are a mixture of varnish, oil, and turpentine. The "fat over lean" rule must be followed, so the medium used in the lower layers must have less oil than that used in the subsequent layers. It is much easier to use alkyd mediums because the alkyd can be used just as it comes out of the bottle without any mixing. If you *want* the alkyd medium to be more fluid, it can be mixed with solvent. This will not influence the drying time, just the fluidity.

When I am painting the objects in a still life, I put only a very small amount of alkyd medium on my palette—just about a nickel-sized puddle. The obvious reason for this is that it is less wasteful and more economical than pouring out a larger amount. The other, and perhaps more important, reasons are:

1) It reduces the amount of chemicals in the air that I am breathing, and 2) it creates fewer odors in my studio. However, when I am painting the toning or imprimatura layer, or background layer, I pour out a whole lot more, especially if it is a medium- to large-size painting.

During a painting session, and even for a few hours after the session ends, it is fine to leave alkyd medium in your brushes. When a painting session is concluded for the day, though, it is important to clean the brushes with solvent. When alkyd medium dries in a brush it can get quite hard. This is best to be avoided. I have rescued many brushes with Murphy's Oil Soap. First, I use solvent to remove as much residue as possible. Then, I work as much oil soap into the brush as I can and wrap the brush up in aluminum foil and a plastic bag so the soap will stay damp in the brush hairs and not dry out. I leave the brush at least overnight and then rinse it out with lukewarm water. Then I work more oil soap into the brush and rinse it again until it is clean. If the brush does not clean or appears to be too damaged, I sadly throw it away.

Linework

There are four things necessary to paint fine lines with a brush: 1) a steady hand; 2) a small round brush (for very fine lines I use sizes 6/0, 10/0, and 18/0); 3) appropriate fluidity of the paint; 4) practice.

Pick up some of the medium with the tip of the brush and swirl it into an edge of the paint on the palette. Mix the two together and then test the mixture on the palette. If the brush mark has a transparent center with ridges of paint on the sides, then the mixture is too thin and has too much medium in it. If the paint doesn't flow off of the brush or it requires so much pressure that more than the tip of the brush is touching the

surface, then the paint is too thick and needs more medium.

It takes practice and patience to paint consistent, steady lines. When I was first learning to paint, I had a teacher who had me practice doing what seemed like *miles* of lines on blank paper—long lines, short lines, thin lines, thick lines, lines of varying widths and lines that curved around like tendrils and corkscrews—pages and pages of lines. I have always been grateful for that teacher, and glad that I wanted to paint badly enough to actually do all of that practice! (For more tips on doing Linework, see the box on page 117.)

Cleaning Up Mistakes

One of the best things about working with oil paint is that it is very forgiving. Mistakes are easy to repair when the paint is still wet, and one of the best tools for doing so is the Wipe-Out Tool.

First I wipe up as much of the paint as possible with the tool, then if absolutely all of the paint has to be removed, I take a clean flat brush and dip just the tip in solvent. I wipe the brush on a paper towel and then use it to very carefully wipe out any remaining paint. After each time I wipe up a bit of paint, I wipe the brush on a paper towel to remove the pigment. If I omit this step, the pigment just gets moved around the surface and not cleaned up.

I keep a couple of brushes just for cleaning up mistakes. I prefer to use synthetic brushes for this because they hold less solvent and they usually have a thinner edge than a sable brush. Plus, sometimes I have to scrub a little bit to get paint residue completely cleaned off of a painting, and I really hate to do that to an expensive sable brush.

In the upper right you can see the area where the chisel tip was used to remove paint. Below that is the area where the pointed tip was used to remove a line of paint.

Cleaning Brushes

There are several steps to properly cleaning a brush:

1. Squeeze out as much of the pigment as possible on soft paper towels. Fold the paper towel into quarters, then sandwich the hairs of the brush between some layers and squeeze the paint out. Do this until no more paint comes out of the brush.
2. Then, rinse the brush in solvent by *gently* running the hairs along the top of the brush cleaning pad. Periodically, squeeze the brush hairs in the paper towel to see if all of the pigment has been removed.
3. If it is a large, expensive, or fluffy brush, like a mop, I clean it with Murphy's Oil Soap. I just work a little bit of the oil soap into the hairs and then rinse it out with lukewarm water.
4. Lay the brushes on their handles to let them dry. If you place them with the hairs above the handle, the moisture can run into the ferrule and dissolve the glue.

HOW NOT TO CLEAN A BRUSH

- Don't drag your brush back and forth on the paper towel. It causes needless wear on the brush and will abrade the ends of the hairs and cause them to break or fray.
- Don't let your brush stand on its hairs in the jar of solvent. This causes the hairs to be pushed out of shape and if the solvent gets up into the metal piece (the ferrule), it can dissolve the glue that is holding the hairs in place.
- Never use hot water to rinse out a brush. It, too, can dissolve the glue that holds the hairs in the ferrule.

Blending

One of the keys to successfully blending oil paint is using colors that are not too different in value, intensity, or temperature. The two colors used here blend all right in a small area, but for a large area it would be much easier to have another color variation in between them. When blending, use the flat side of the brush; it will leave less marks than if you use the edge. Apply only enough pressure on the brush to move the paint.

Use the largest brush available to blend paint in large areas, such as a background. Mix the paint on the palette to make sure that the change from one color to the next is subtle. Once you are painting, if you notice that a new color is a lot different than the previous one, wipe it up and mix a color or several colors to place in between the two. The time you spend mixing more paint will not be wasted—you will make up for it with the time you save blending and the transitions of color within the blended areas will be more successful.

As you pick up each brushload of paint, work in a small amount of medium. To do this, place just the tip of your brush in the medium and then move your brush back and forth in an edge of the paint. This will make your paint more fluid and easier to blend. It will take some practice to know how much medium to use—too much, and the paint will be too clear and slippery; too little, and the paint will be too stiff. Don't mix the medium into the whole pile of paint; it will cause the paint to dry too quickly and you will not be able to use it later.

Paint large backgrounds in natural light. You can best perceive where the blending isn't quite right yet, and where it is lovely and subtle.

1. **When painting the first color, be sure to leave a soft or fluffy edge into which you can blend the next color.**

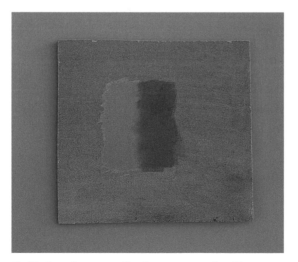

2. **Paint the second color next to the first, slightly overlapping the two colors. Leave a soft edge on both sides of the second color.**

3. **Blend the two colors using criss-cross strokes of the brush. Work down the length of the blending area, using the criss-cross motion to bring some of each color into the other.**

4. Then, work the brush from side to side to smooth out the in-between area. If the background shows through too much, then you are using too much pressure. Reload the brush and repeat the process.

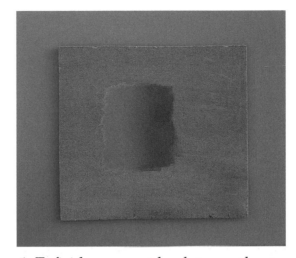

5. To finish, use a mop brush to smooth out the top surface of the paint and to eliminate any brush strokes and ridges. The end result should be a smooth and subtle transition between the two colors.

How NOT to blend

Here, the colors are painted side by side with a hard edge between them. The hard edges are more difficult to blend, because there is less color available to work into the joining area.

Don't blend across the center with the brush straddling the two colors. While this will soften the edges, the paint will get very thin and it will look like there is a "hole" between the colors.

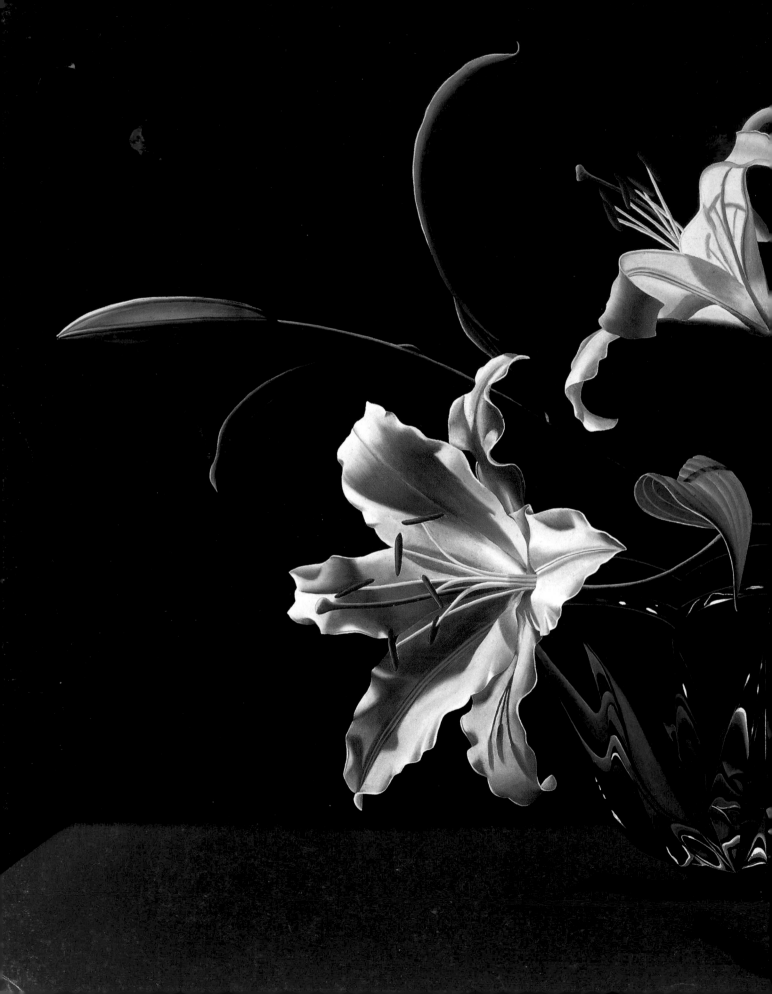

CHAPTER TWO

*Preparing
the Still Life*

Crystal and Lilies
Oil on hardboard, 24 x 36 inches
Collection of Clark Olson

*Sometimes when I buy flowers or cut them
in my garden, I have a specific idea that I am
trying to put together. Other times, though,
I experiment with the flowers in the light and
watch what happens. When this composition
came together in the light, I knew it could make
a very special painting.*

Lighting the Set-Up

Lighting is every bit as important to your composition as the objects you choose to depict. The lighting can set the mood, whether it is bright and upbeat or low and mysterious. As you go about your day, take a moment now and then to notice the light and how it makes you feel. In your studio and home, pay attention to the quality and angle of the light as it changes through the day and throughout the year.

Light is very attractive to the human eye and we are very drawn to it, whether it is real light or the illusion of it in a painting. One of the greatest masters of light was Rembrandt van Rijn (Dutch, 1606-1669). His intriguing use of light is a big part of why his work still attracts so much attention and admiration today. He used the brightest light to illuminate the most important areas in his paintings, and then let the light abruptly dim into the mystery of the shadows. Other great masters of light were Caravaggio (Italian, 1572–1610) and Artemisia Gentileschi (Italian, 1593–1652). They treated light in a style referred to as *tenebroso,* which means "the dark manner." In these paintings, there are usually many more square inches that are dark rather than light, and there is an abrupt change from light to dark with very few middle values. These two elements combine to create paintings that appear very dramatic.

There are three qualities to light: temperature (or color), intensity, and direction. The TEMPERATURE of the light, whether warm or cool, affects the color of the objects. The light at sunrise, late afternoon, and sunset is very warm and will make objects appear to be more golden or red. In contrast, sunlight during the middle of the day appears rather cool because of the reflection of the sky, so objects will appear bluer when viewed midday.

The colors of objects viewed in the late afternoon and at sunset appear warmer than colors viewed midday. The shadow areas are not as dark as those when incandescent light is used, because the intensity of sunlight illuminates all of the objects that are around the still life set-up, and these objects reflect light into the dark areas of the set-up.

Incandescent light also emits a warm glow, yet it is not as intense as sunlight. Since light is not reflected into the set-up from other objects, the shadow areas are darker than if the objects were in the sunlight. So, in incandescent light there is more contrast between the light and dark areas of the set-up.

The INTENSITY of the light will affect how bright or dim the still life set-up appears to be. When the sky is clear and bright there are brilliant lights and very dark shadows, but often not much of the middle values. If a thin cloud passes in front of the sun the intensity will lower a bit, and on an overcast day the light is evened out entirely, with no highlights or dark shadows.

Incandescent light is much easier to control than sunlight. There are several ways to control the intensity of incandescent light:

1. By the intensity of the lightbulb: 100, 200, 300 watts, and so on.
2. By how close the light is placed to the objects: If the objects are close, the light appears bright; if the objects are far away, the light appears dim.
3. By placing sheer fabric over the light fixture to soften or diffuse the light. (Caution: Never let the fabric touch the lightbulb and never leave a fabric-covered light unattended.) Similarly, diffusing filters or gels can be mounted in frames that fit on spotlights.

The other quality of light to consider is its DIRECTION. With sunlight the only way to change the direction is to change the orientation of the objects in relation to the sun. The direction of artificial light is easier to control.

Experiment lighting the set-up from different angles to find the most engaging light and shadow pattern. Consider what elements in the arrangement you wish to emphasize, and consider how the shadows are cast throughout the composition. In the example shown, the light from the right nicely illuminates the fruit on the table and casts more dramatic shadows than when light is shone from the front. In addition, when the light is at a height just a little bit above the set-up it casts dramatic shadows, but when the light is shone from too far above, the shadows are lower and less interesting.

On an overcast day, objects appear evenly lit with no highlights or dark shadows and only middle values, which can create rather flattened forms.

When the light source is far away from the set-up, the light will appear dim.

Notice how light shone from the left side illuminates the drapery instead of the more important compositional elements—the fruits.

If you are photographing indoors or close to an outdoor wall, be aware that brightly colored walls will reflect on all of the objects and shift their color accordingly. Light-colored walls will reflect light, which can be beautiful in the shadow areas; dark, dull walls will reflect very little light. Years ago I did a series of paintings using a lot of silver objects with white drapery. The only intense colors in the compositions were the fruit. I wanted to control the shines and reflections on the silver, so I placed three-sided boxes that I had spray-painted gray around my still life set-ups.

I usually prefer the intensity of sunlight and like the angle of the light in late afternoon and early evening. The angled light lends drama to a still life because of the patterns and deep shadows it creates. And it *is* the most "natural" light for fruit and flowers. During the winter, when the sunlight is lower in the sky, I can photograph my set-ups indoors because my studio has south-facing windows. It is good for dramatic effects such as those seen in *Crystal and Lilies* (page 42). When the sun is higher in the sky in the spring, summer, and fall months, I can't photograph indoors, so I take all of my still life materials—flowers, fruit, vases, bowls, marble tiles, and draperies, even a table from my entry hall—out to the backyard and photograph there.

When you assemble your still life set-ups, think about what you want to communicate through your painting and play with the light until it supports your ideas. Often I have found that as I play with the light I discover better situations than the ones I originally planned on.

On the Move
**Oil on hardboard,
36 x 42 inches
Collection of the
St. Louis University
Museum, Missouri**

Many flowers will bend in the direction of the light. When I placed these calla lilies in this vase the stems were straight. The following morning they had moved into the graceful curves that you see here. The celadon elephant turned out to be a great element to balance the flowers.

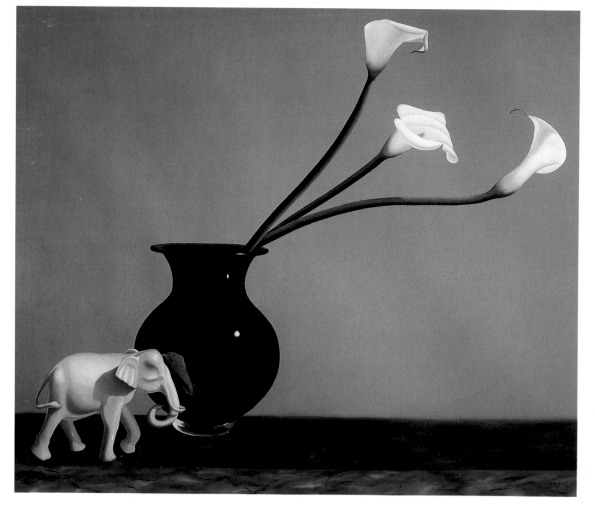

Photography

I work from photographs because my models, which are fruits and flowers, perish quickly and oftentimes the lighting is momentary (and some flowers move to follow the sun, which changes their position). With photography, I can capture a specific stage of a bloom and a specific light as it falls on a flower or piece of fruit. And photography allows me to paint flowers and fruit that are out of season or when the sunlight is dim. Nothing can take the place of *really* looking at and seeing the objects and light, so I not only work from photographs, but also from notes, both hand-written notes and painted Color Notes (see Color Notes, page 51).

I use two different cameras to record my images. When I am photographing with natural light, I use either a 35mm camera or a digital camera. When I am using artificial light, I use the digital camera only.

Taking photographs using a 35mm camera and artificial light can be a bit tricky. The light that I use is either incandescent or halogen, each of which has a specific temperature. There is film that is balanced to the temperature of each kind of light, but it is expensive and not always readily available. The alternative is to use film balanced for sunlight and a blue color correction filter that offsets the difference in the temperature of the light versus the film. Compared to sunlight, artificial light is very weak, so it is necessary to use 400 speed film. Low light requires photographing at such a slow shutter speed that this "higher speed" film is necessary for a correct exposure. To eliminate blurring, use

a tripod and cable shutter release for long exposures. (Newer cameras are less mechanical and more electronic, and may have an electronic shutter release.)

I did artificial light photography this way for years, but when digital photography became widely available, I found that it was great for photographing in artificial light because temperature balance is not a problem. When working with a digital camera I use a feature called "white balance" to correct the warmth of incandescent and halogen light. The photographs turn out really well; however, even with a good printer, the digital photographs do not have the depth of color or resolution of traditional photographs. Neither system is perfect, but they both produce photographs that are acceptable references for painting.

The kind of camera that you have can make a big difference in the quality of the photos that you take. I use a Canon AE-1 35mm camera that I bought in 1979. I have kept the camera well maintained and have only taken it to a camera shop for a few repairs. My lens is a 28mm to 70mm macro-zoom. With it I can take shots that appear to have been taken from several different distances without moving. It also allows me to take good detail shots. When I need to do close-up details that are beyond the ability of the lens, I use extension tubes or rings. These have no lenses in them, but instead simply extend the lens from the camera body so that you can take close-up shots. They can be used individually or together. The more the lens is extended from the camera body, the more the object being photographed is magnified.

35mm camera, blue filter, tripod, shutter cable release, and 400 speed film.

If you use extension tubes, like the ones shown here, you will need to use a slower shutter speed to allow more light to come into the camera. A secondhand camera shop is a good place to find extension tubes at an affordable price.

If you do work from photographs you should be aware of how colors can shift depending upon the brand of paper they are printed on and how new or old the chemicals are that were used for processing the film. Some brands of paper create an overall cool effect with an emphasis on the blues and greens, which is great for landscape pictures. Other brands create an overall warm effect with an emphasis on the reds. The freshest chemistry is the truest, so I recommend taking your film somewhere that does a pretty high volume because the chemistry is usually changed on a regular basis. After your roll(s) of film have been developed and printed, take a strip of negatives to two or three different places to be printed and decide which facility works best for you. (If possible, develop a relationship with whoever is doing your processing so that whenever a problem arises they can help to resolve it.) You will find a great variety in pricing from very inexpensive to very costly, but don't be over-influenced by cost. When the still life set-up and lighting are long gone, the photographs will provide and sustain both the inspiration and passion to take your painting from conception to completion.

Digital photography is another matter. If you are good at manipulating images on the computer, you will have even more control of the outcome of your digital photographs. But remember that digital photography and printing do not as yet have the color sensitivity or crispness of photographic film. And neither film nor digital photography have the sensitivity of the human eye.

The bottom line is this: Is the photograph as attention getting and beautiful as the original composition? If it isn't, then I won't be inspired to paint from it and a wonderful opportunity will be lost. Sometimes it can take me years to get around to painting a particular composition. Photos and Color Notes have to be very compelling because memory just isn't enough. It's important to take your time setting up the still life and to take *lots* of photos. This is the time to let your creativity fly.

Some things to keep in mind while setting up and photographing a still life:

- **Play with the direction of the light to find out what best captures the look and feel you want your still life to have.**

Changes in the direction of light influence both the feel and look of the still life set-up. Here, the arrangement is lit from the left, creating dramatic shadows across the tabletop.

In this image, the arrangement is brightly lit from the right, illuminating the rose and highlighting the leaves. This lighting gives the still life a much more exuberant feeling.

Notice how a simple change in background color can greatly affect the look and mood of a still life set-up.

- Try several different backgrounds behind a set-up. I use various colors of foam-core boards; some are manufactured colors, some are spray-painted, and sometimes I cover the boards with fabric. I use foam-core because it stays rigid and straight propped against the wall in my studio where I store it, whereas mat board curls.
- Take plenty of detail photographs. Be sure they are all at the same angle; you don't want some of the objects in your still life to appear to be seen from a higher or lower angle than the rest. Keep your line of sight even. The reflections and shines on the glass are especially important both to record and keep consistent.
- Take photos that show varying amounts of background, some with a little and some with lots. It's amazing how different a set-up can look depending upon the amount of background you use.

 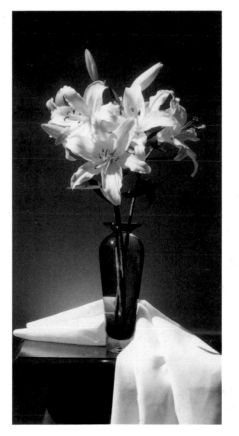

Experiment using more or less background to find the most pleasing composition. There is always a delicate balance between too much space in a composition and too little. Too much space can diminish the importance of the flowers. I find the amount of space in the photo on the right more appealing, as it allows the flowers to breathe without overpowering them.

Horizontal compositions often have a quiet and serene aspect, while vertical compositions are generally more dynamic and uplifting.

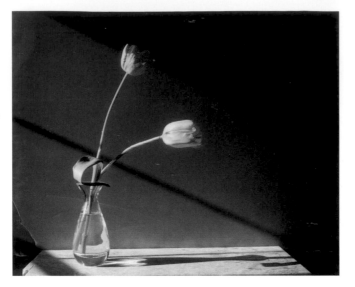

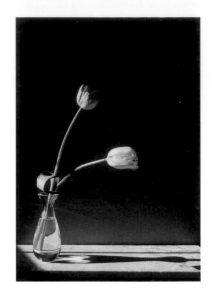

- If you are photographing in low light, be sure to light your set-up from the left and the right. Sometimes the exposure isn't long enough to register the details in the shadow areas, and those details will be necessary during the painting process.
- Look at the objects from slightly different angles—side to side and up and down—you may see a shadow or highlight that you can emphasize. Rotate things just a little bit each way in relation to the sun. You might find something wonderful to include in your photographs.

As you take your photos remember that they will be your lifeline to the real set-up when you are painting. If they are fuzzy or out of focus, or you just didn't take enough detail shots, then it will be impossible to create an accurate image. Don't try to fake it, especially if you are a beginner—it won't work. So many bad paintings could have been avoided if the reference material had been better. Take your time as you photograph. Get to know your camera, and remember that it is far better to have too many photos than to have too few.

Information from different photographs can be combined in the painting. In this image, the cast shadows of the stamen and pistil in the forward flower is really interesting.

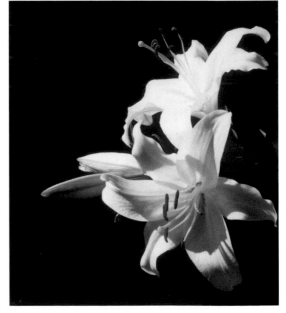

In this arrangment, the bottom of the flower petal reveals more about the form and direction of the petal. The green bud would be most interesting with the shadow patterns seen here.

Color Notes

Color Notes are a great way to capture the colors of a still life set-up. While photos are great, they have their limitations, for example they are not nearly as sensitive to color and its subtleties as the human eye. So when I have finished photographing, I make notes of how I perceived the colors. It is also important to mix the colors in the same light that the set-up was photographed in. Colors appear differently as the light changes throughout the day, with objects appearing warmer at sunrise and sunset, and cooler at midday. If I am photographing a set-up in the sunlight, I take my palette to where the set-up is and mix the colors as if I were actually going to paint the still life right away. It is important to do this especially with flowers because as they age not only do they wilt, but their colors change, usually becoming more dull and transparent. I want to paint the colors as they were when the flowers were fresh and alive.

Mix the colors as accurately as you can. Be sure to label what colors you used from the tube and what ones you mixed together, and label the palette sheet for what photo(s) it goes with. (This is not the time to say, "Oh, I will remember that.") My Color Note palette usually looks like a road map with arrows pointing to what colors I used and how I mixed them. It's my personal shorthand and it works for me. You might want yours to look a little bit neater and organized (I do too, but it rarely works out that way).

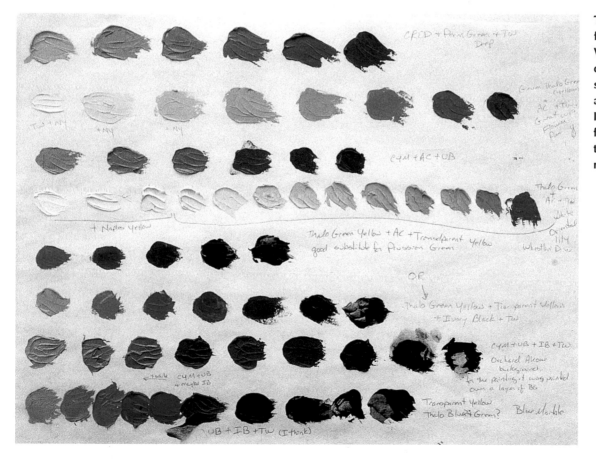

These are the notes for the painting *Whislin' Dixie*, shown on page 139, and some other paintings as well. Note how I even include notes for the marble table that the vase is resting on.

In addition to Color Notes, I also write notes to myself about elements I want to be sure to include, emphasize, minimize, or change in any way. Then, when I get the photographs back from processing I look them over and make additional notes.

Color Notes inspire and inform me when I am working, and they keep me from spending time searching for just the right mixture. In addition to my Color Note palette, I also keep notes of successful paint mixtures for various kinds of flowers to which I can refer to as needed. And I keep notes of background colors that I like. The foam-core backgrounds are just a starting point, usually just to determine value and perhaps temperature. After that I must figure out what color background will enhance the flowers or fruits that I am painting.

By the time I get around to painting a particular image, the flowers and fruits are usually long gone. But the vase, bowl, compote, or other non-organic objects remain in my studio. Especially when drawing, it is important to have these objects on hand. I set them up in the same position and with the same lighting as in the photograph, so I can draw them without any lens distortion. And sometimes if I am having trouble drawing a curve or other contour of an object, I hold the object in my hands, close my eyes, and feel it with my fingertips. Sometimes my fingers can "see" better than my eyes.

Being a painter is a job that requires all of the senses, not just sight. Even if I can't use the fruit or flowers that I originally photographed, I will bring new ones into my studio for inspiration. Sometimes the delicious smell of a peach will remind me of how sweet and luscious the fruit can be. Or holding a pear and feeling its form will remind me of how sensuous and appealing its curves are. The small amount of drag that my fingertips feel along the skin of a grape reminds me of its grayish "frost" and glowing color. And the snap and sweetness of a bite of apple can make me remember how firm and shiny they are. All of these things inform my sense of vision and creativity. And the more passionate I feel about something, the more likely it is that I will communicate that passion in paint.

Here, my handwritten notes remind me to pair a light underpainting and rich red glaze to best capture the vibrant colors of the rose petals I planned to paint.

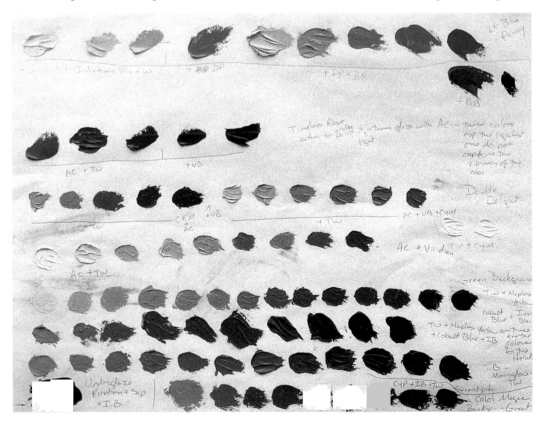

Pansies come in an array of blues and pinks and purples. I used these Color Notes as a reference when painting *Sassy Faces* (page 14).

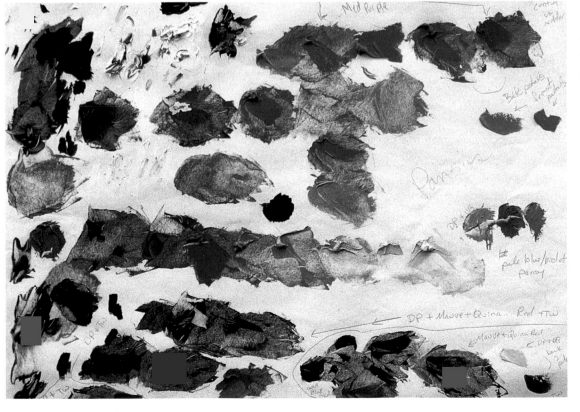

I can use the same pansy Color Notes as a reference when painting other still life arrangements that include these precious flowers.

Drawing with Accuracy

Illumination
Oil on hardboard, 28 x 42 inches
Collection of John and Sandy Velotta

I was enthralled with these miniature calla lilies from the first moment that I saw them—they looked like floral diamonds. And in the sunshine they appeared as if white flames of light. If you look closely you will see that the lilies have some red-violet edges. I love painting details like this; they are something for the viewer to discover as they look more closely at the painting.

Basic Techniques

Every realistic painting has to start with a drawing as its foundation. The drawing works like a road map with directions for how to get to where you want to go. And the more information it contains, and the more accurate that map is, the better the chances are of successfully arriving at the desired destination. So often artists jump into the process of painting only to soon figure out that they aren't going where they want to simply because they didn't take the time to accurately construct the drawing. The better the drawing is the better the chances are that the painting will turn out well. It is a *lot* easier to recompose and improve or fix problems in your composition with a pencil and eraser than it is with brushes and paint.

I have always preferred to do a detailed drawing prior to beginning the painting process and dealing with all of the problems that must be solved with paint. For me the drawing is a way to really get to know the image and its nuances and subtleties. Sometimes I make notes on the drawing about elements I want to be sure to see or change, or color qualities I want to enhance or diminish.

Tight realism requires that the drawing be as perfect as possible, otherwise the illusion just won't work. So I use several methods to make sure that my drawings, and therefore my paintings, are as accurate as possible. In addition to my drawing skills I use some drafting techniques, including folding the drawing to ensure symmetry, drafting ellipses, and using clear-plastic grid rulers to make sure that right angles and parallel lines are true. And I use one-point perspective to draw parallel lines that go deep into the space of the painting.

An assortment of drawing materials, including rulers, pencils, and erasers.

DRAWING MATERIALS

- 12-, 18-, and 24-inch clear-plastic grid rulers (I use C-Thru brand rulers.)
- Tracing paper (The hard finish of tracing paper makes it easy to completely erase errors, and the transparency allows you to accurately place and re-place the drawing over the painting. I prefer to use tracing paper from a large pad rather than on a roll. Rolled paper is often difficult to lay flat.)
- Kneaded rubber eraser or white vinyl eraser (I prefer the white vinyl eraser over the traditional kneaded eraser because it erases more completely. The Sanford Magic Rub Eraser is my favorite.)
- White stick drafting eraser and eraser holder (a pen-style eraser and eraser holder used for precision work)
- Erasing shield (a thin, flexible metal shield with various sized and shaped openings that allow for precision erasures while protecting the drawing)
- 2H pencils (I like the 2H because it smears very little)
- Pencil sharpener (I prefer battery or electric operated sharpeners, but a small hand-held one works, too)

Folding

Folding a drawing is a great way to make sure that the two sides of an object are symmetrical.

The fold will become the vertical axis for the object and a reference for drafting its ellipses and for squaring the drawing.

First, draw the object as well as you can. Then, fold the drawing vertically down the center of the object. Examine the two sides and decide which one is the best.

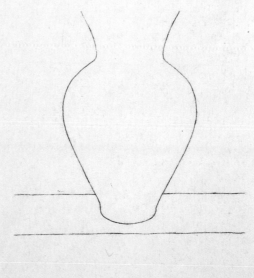

Trace the best side onto the other side. To trace, fold the paper with the back sides facing each other and trace the preferred line onto the other side of the object.

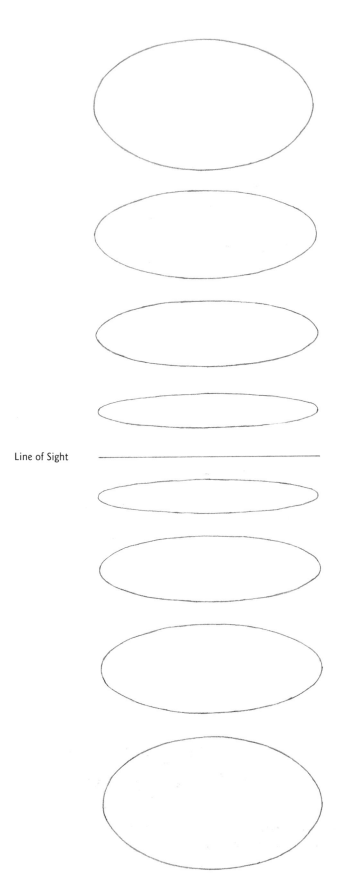

Line of Sight

Drafting Ellipses

Ellipses are difficult for many people to draw accurately. I struggled with them until I found the book *Painting Sharp Focus Still Lifes* by Ken Davies and Ellye Bloom (Watson-Guptill Publications, 1975). After drafting ellipses *many* times and seeing how they *should* look when they are drawn correctly, I could finally draw ellipses accurately without having to draft them. But if I need to check one for accuracy, I draft it just to be sure.

An ellipse is a circle in perspective. When a circle is level with our line of sight it appears to be a line. When trying to create volume and depth, it's best to present the circle as an ellipse because it implies the depth and width of the object, whereas a line looks very flat. Frequently we look down on circles, such as when looking at a vase, bowl, can, or flower-pot sitting on a table (circles appearing below the line of sight). Occasionally we look up at circles, such as when looking at a water tower, a clock on a wall, or a dish on a high shelf (circles appearing above the line of sight).

Here is an example of how ellipses appear at various degrees above and below the line of sight.

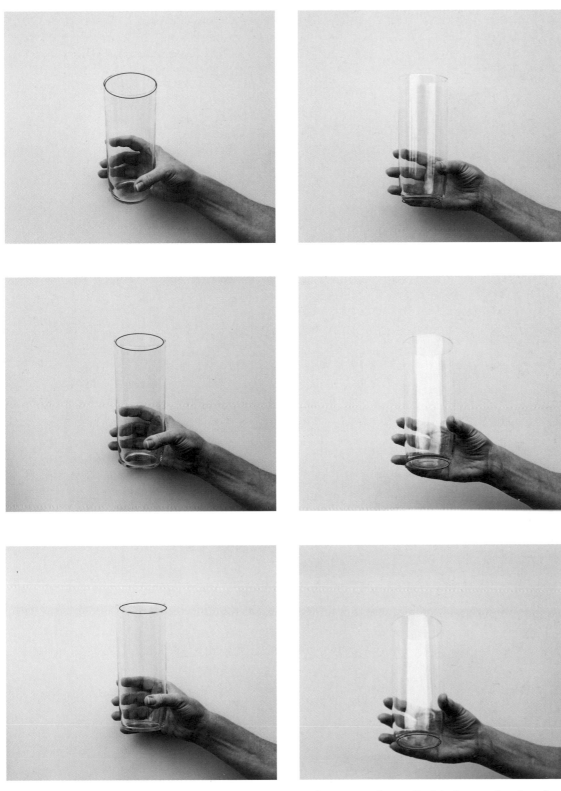

Column 1: A clear cylindrical vase showing the top ellipse from various angles.

Column 2: A clear cylindrical vase showing the bottom ellipse from various angles.

Drafting an Ellipse

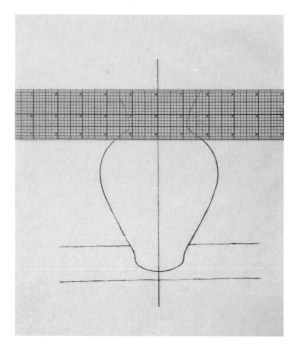

1. Fold the drawing vertically down the center to mark the vertical axis of the ellipse. To mark the horizontal axis, lay a clear-plastic grid ruler across the center of the ellipse, perpendicular to the fold line. Mark the center front edge of the ellipse where it comes the most forward as point "C."

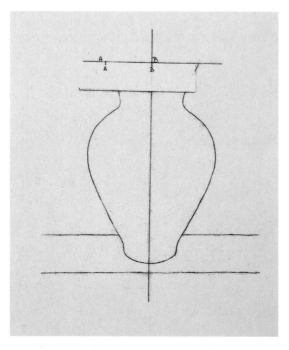

2. Mark point "B" where the two axes intersect. On the horizontal axis, mark point "A" at the farthest left point on the object edge. Measure and mark the distance between points "A" and "B" on a small strip of straight-edged paper.

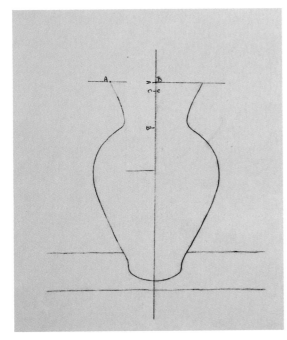

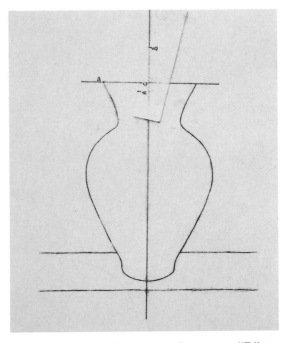

3. Move the small strip of paper so that point "A" on the sheet of paper is aligned with point "B" on the drawing, as shown. Mark the position of point "C" (the front edge of the ellipse) on the small strip of paper.

4. Lay the strip of paper so that point "B" is on the vertical axis and point "C" is on the horizontal axis, as shown. Holding the strip of paper in place, lightly mark the spot on the drawing where strip point "A" now falls.

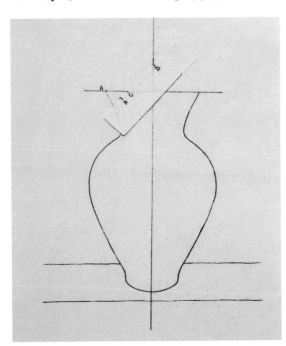

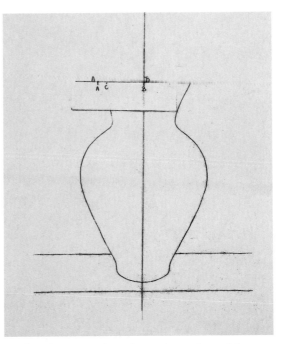

5. Continue moving strip point "B" along the vertical axis and strip point "C" along the horizontal axis, marking the spots where strip point "A" falls on the drawing.

6. Continue moving the strip and marking the position of strip point "A" on the drawing until strip points "A" and "B" match points "A" and "B" on the drawing.

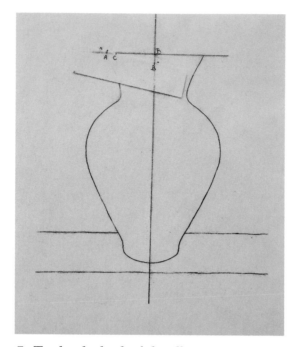

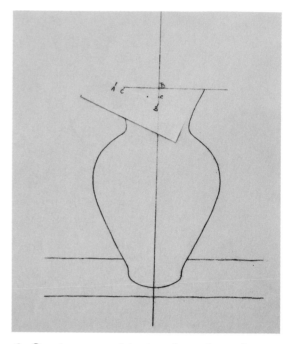

7. To plot the back of the ellipse, move the paper strip so the strip point "C" is on the horizontal axis and strip point "B" is on the vertical axis marking the position of point "A" on the drawing, as shown.

8. Continue repositioning the strip so that strip point "C" is on the horizontal axis and strip point "B" is on the vertical axis below point "C" on the drawing. Lightly mark points where strip point "A" lands on the drawing.

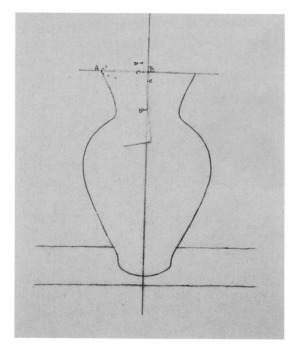

9. Continue to plot the left side of the ellipse until strip points "A," "B," and "C" are aligned on the vertical axis, with strip point "C" matching point "B" on the drawing.

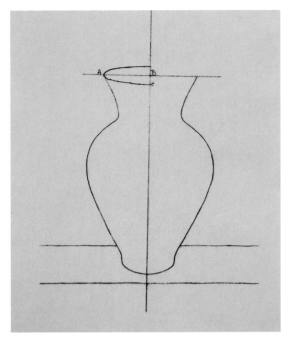

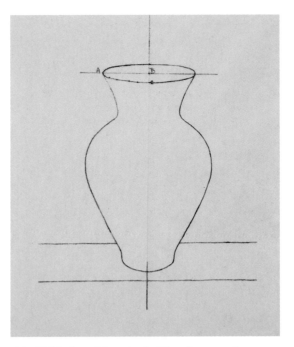

10. To draw the ellipse, draw a pencil line connecting the dots. Smooth the line so that it is rounded, and not a series of small straight lines.

11. Fold the object in half and trace the drafted ellipse onto the other side of the drawing. To trace, fold the drawing in half again along the vertical axis, with back sides facing, and trace the ellipse onto the other side of the drawing.

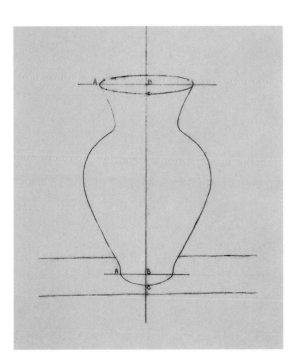

12. The ellipse at the base of the vase can be drafted in the same manner. Notice that the distance between points "B" and "C" on the drawing is increased on the base of the vase, because that ellipse is farther down from the line of sight (see illustration on page 58).

Squaring the Drawing

Clear plastic rulers have grid lines on them every ¹/₈ inch in both directions. With these grid lines I can not only measure distances, but I can make sure that table lines are parallel to the lower edge of the painting, and that the center lines of vases and bowls are parallel to the edges of the drawing and perpendicular to the table line. I usually check all of these lines several times before I transfer the drawing to the prepared board.

1. To true up the table lines, lay the clear plastic ruler horizontally across the drawing so that one of the vertical lines on the ruler matches up with the vertical axis of the object. Draw the back edge of the tabletop, stopping the line at each side edge of the object. Reposition the ruler in front of the object, as shown.

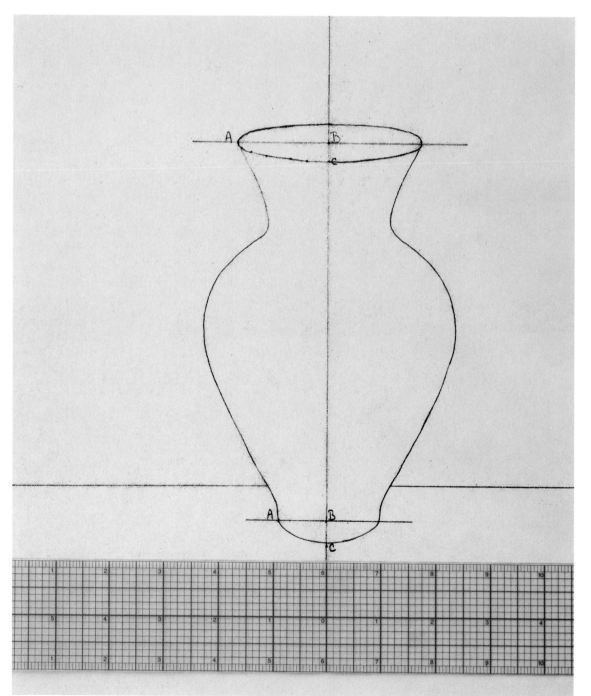

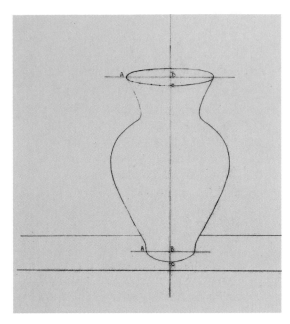

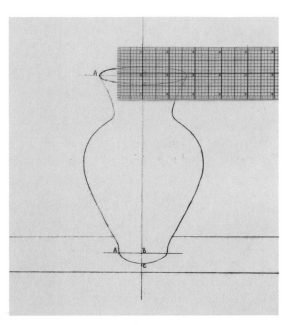

2. Draw the front edge of the tabletop parallel to the back edge. Remove the ruler and check that the lines of the table are parallel and perpendicular to the vertical axis of the object.

3. To draw the outside edges of the drawing, lay a clear plastic ruler horizontally across the object so that one of the lines on the ruler matches up with the vertical axis of the object. Measure to the side edge of the drawing and make a small mark. Do this at least two more times, then draw a line connecting the marks. Repeat on the opposite side.

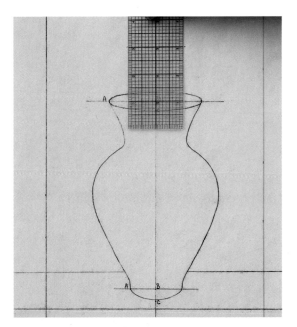

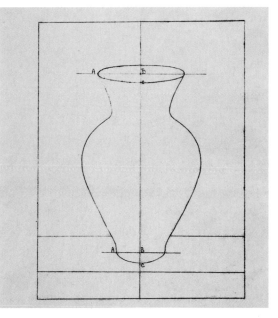

4. Next, lay the clear plastic ruler vertically across the object so that one of the lines on the ruler matches up with the horizontal axis of the top ellipse. Measure and mark the top and bottom edges of the drawing just as you did the side edges.

5. Repeat the steps to draw the lower outside edge of the drawing. When you are done, all outside edges of the drawing should be perfectly perpendicular and aligned, as shown. To finish, erase all pencil lines beyond the outside edges of the drawing.

Linear Perspective

Linear perspective is a mathematical system for creating the illusion of space and distance on a flat surface. To use linear perspective, an artist must first envision the painting surface as an "open window" through which the viewer's eye enters into the illusory three-dimensional space of the painted world. A straight line is drawn to indicate the horizon line, which is at the eye level of the viewer.

One-Point Perspective

Common illustrations of one-point perspective are of railroad tracks or a straight road receding into the distance. The same concept can be used in still life drawing and painting to depict tabletops, window frames, or even walls as they appear to recede into three-dimensional space. While in still life painting, one is generally not trying to create a great amount of depth, linear perspective should still be applied if the illusion is to be successful.

One-point perspective is constructed around a single vanishing point. The first step is to determine the horizon line, or the viewer's line of sight in the drawing. Next, mark the vanishing point, that is, the theoretical point on the horizon line where all of the parallel lines moving into the painting would eventually meet. Note that these lines, or "visual rays," connecting the viewer's eye to the vanishing point often continue beyond the lines of the object itself.

To draw the sides of a tabletop using one-point perspective, draw a line from each front corner of the tabletop to the vanishing point, as shown. Determine where the back edge of the table should appear. At that point, draw a line, parallel to the front edge, connecting the two side edges. If a side of the table is visible, draw a line extending down from the back side corner.

A common illustration of one-point perspective is of the parallel lines of a road or railroad tracks receding into the horizon.

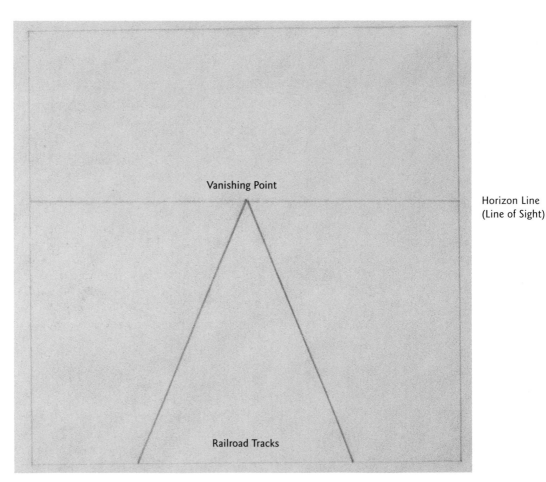

Vanishing Point

Horizon Line
(Line of Sight)

Railroad Tracks

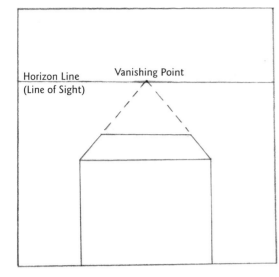

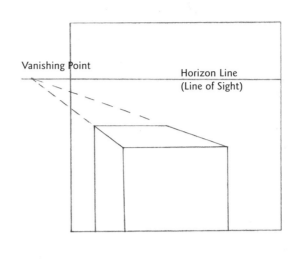

The horizon line is the line of sight in a drawing. The viewer is looking up at everything above the horizon line and down on everything below it.

The vanishing point can be within the drawing, or outside of it. In this example, the vanishing point is beyond the left outside edge of the drawing.

Two-Point Perspective

If the tabletop is at an angle to the viewer, then there will be two vanishing points, one for each set of parallel lines. First, locate the horizon line and the vanishing points. Again, they can be outside of the edges of the drawing. Draw the front corner edge of the tabletop (line "a"). Connect the top and bottom of this line to each of the vanishing points (lines "b"). Draw the back side corner edges (lines "c"). Draw a line connecting the top of line "c" on the right side of the table with the vanishing point on the left side of the drawing. Draw a line connecting the top of line "c" on the left side of the table with the vanishing point on the right side of the drawing (lines "d"). Lines d intersect at the back corner of the tabletop.

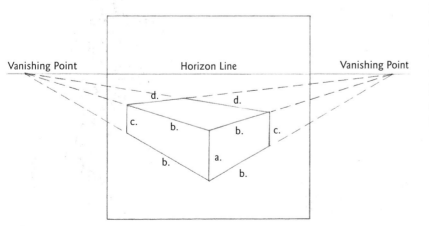

In two-point perspective, the sides of the object vanish to one of two vanishing points on the horizon. The vertical lines of the object have no perspective applied to them.

Fruit Compote Drawing

You really get to know something when you draw it. It's then that you truly begin to analyze your still life set-up. I not only draw the contours of the objects, but much of the light pattern and details as well. If there are any details that just don't make sense, I either change them or leave them out. This is a chance to edit the photograph in order to make a better painting. Look carefully to see if there are any shapes in the light pattern that flatten the forms, and if so, change the shapes so that they enhance rather than detract from the set-up. If there is a shape in the light pattern that gives the impression of some other object, such as a "fish" or "duck" shape, change it. This is also a good time to add-in details from other photographs that you find especially appealing. For example, you may prefer the way a piece of fruit is oriented in one photograph, or the light pattern on a petal or leaf. Be sure when combining elements from different photographs that the lighting is consistent.

I find that no matter how careful I am in the initial still life set-up, there is always something I want to change. In the drawing that follows, I eliminated a couple of cherry stems. They went in too many different directions and caused too much confusion and movement. To begin, I took two 19- by 24-inch sheets of tracing paper and taped them together. (I have only found tracing paper larger than 19 by 24 inches on a roll, and the hassle of the paper constantly rolling up wasn't worth the advantage of having larger sheets.) I almost always paint objects a little bit larger than life, so I measured the width of the compote and added an inch. I then used that measurement to set the proportions of everything else in the drawing.

HELPFUL HINT

I use a horizontal measurement to set the proportions of a drawing because vertical measurements change depending upon the position of the viewer: looking straight on it is one measurement, and looking from above it is another. But no matter which point of view, the horizontal, or width measurement, stays the same.

I decided that I liked the vertical format better than the horizontal format, but I didn't like the way the far left fold of the drapery was arranged around the stem of the compote.

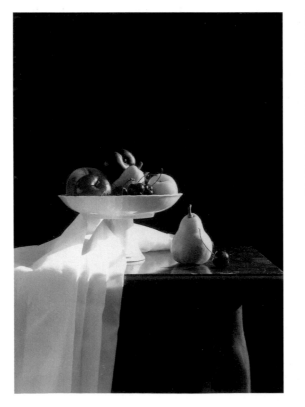

I looked through all of the photographs that I shot with that set-up for one with a similar direction of light, but where the fold of the drapery was more pleasing. I used this drapery arrangement in my drawing.

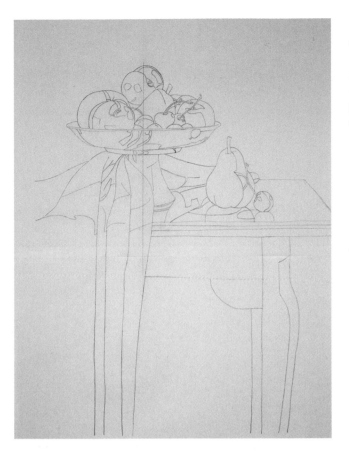

1. To begin, I drew the basic objects and the shapes of the light and shadow areas. I folded the paper so that the sides of the compote bowl matched up. The fold line became the vertical axis of the compote.

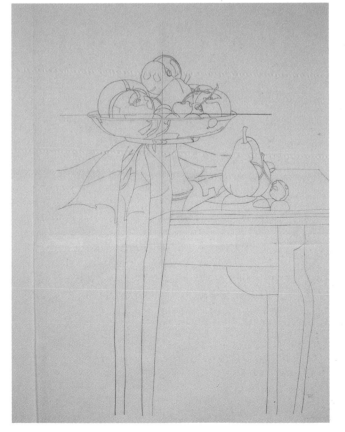

2. Next, I drafted the ellipses at the top of the compote, the base of the bowl, and the base of the stem. I laid my clear plastic grid ruler across the vertical axis and drew the horizontal axis of the ellipse. Note: I often draft ellipses on the back of the drawing, so that I do not disturb the rest of the drawing.

3. *The rim of the compote has a visible thickness. There are two ellipses, one defining the inside rim, and one defining the outside rim. I first drafted the interior ellipse, and then drew the exterior ellipse using the interior ellipse as a guide. (The exterior ellipse could also be drafted by shifting the horizontal axis down slightly and moving point B slightly to the left.) I smoothed out the lines so that they were rounded and not just a series of small, straight lines.*

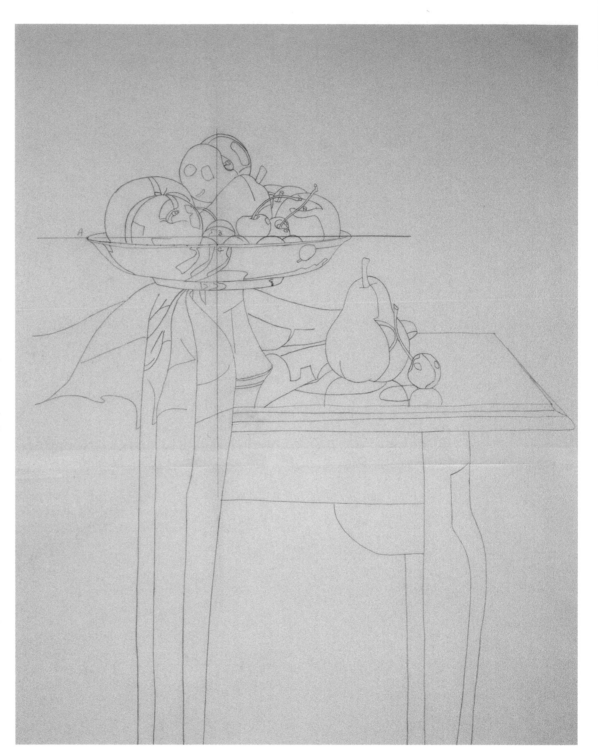

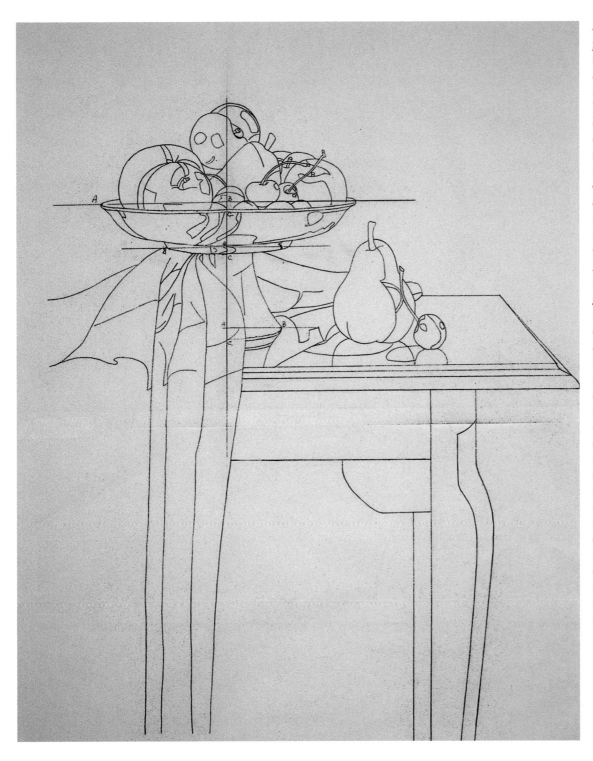

4. I folded the paper in half and traced the drafted ellipse to the other half of the drawing. Then I redrew the best side of the compote and traced it onto the other half to be sure it was symmetrical. I drafted the other two ellipses, using their relative measurements for points A, B, and C. I laid the clear plastic grid ruler across the vertical axis of the compote to draw the horizontal lines of the tabletop edges and the shadow on the front edge of the table. I used the grid lines on the ruler to square up the lines of the drawing. I then used the grid on the clear plastic ruler to draw the vertical lines of the table legs. These vertical lines should run perpendicular to the horizontal edge of the tabletop.

The last step in the drawing process is determining where the outside edges of the drawing will be. For this, I use corners that I have cut from framing mats. Several corners with different length edges can be cut from one piece of mat board. When I place the corners on the drawing I can see how the drawing looks framed without any visual distractions. I experiment with different positions of cropping the drawing until I find what looks best. At this time, it is important to bear in mind that the interior edge of the actual picture frame will cover about $^1/_4$ inch on each side of the painting. Allow for this amount of additional space around the drawing when determining the outside edges.

5. *First I placed the mat edges on the drawing so there was a lot of space above and quite a bit to the left of the compote. I wasn't happy with this arrangement for several reasons:*
A. *The amount of space above the table was too similar to the amount of space below the table;*
B. *The importance of the fruit was diminished by the large amount of surrounding space, and the dark color that I planned to paint the background space with would have appeared too heavy;*
C. *The amount of space on the left side of the drawing placed the compote and the fruit on the table too much toward the center of the composition, making it too static.*

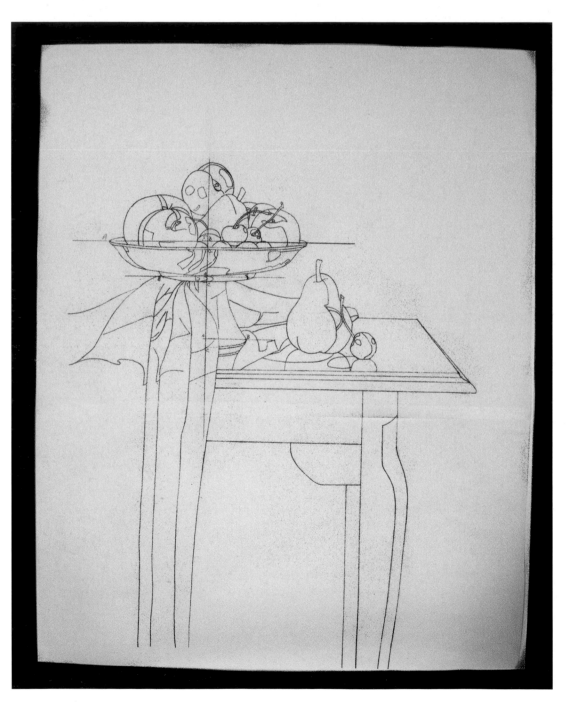

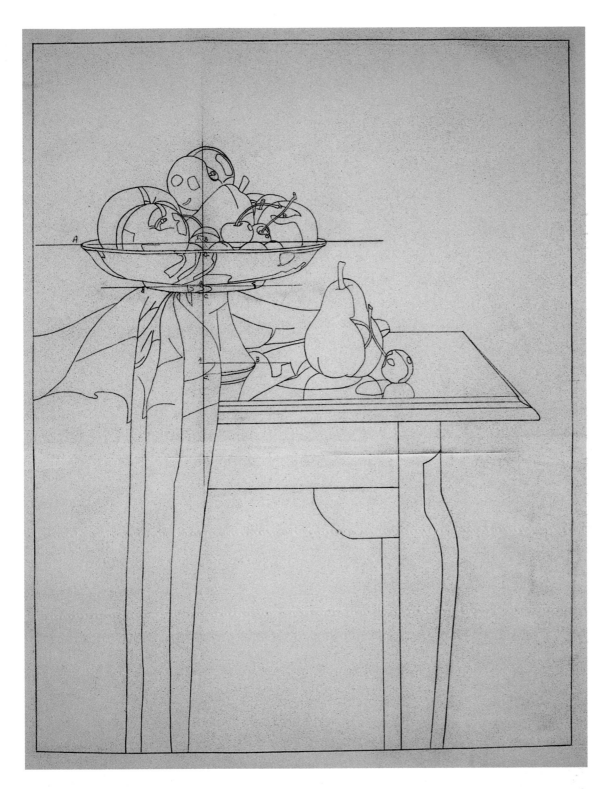

6. I moved the mat board corners to close in the space at the top and left side, so that:
A. The size of the space above the table is different from the space below, making the composition more interesting;
B. The fruit became more visually important as the size of the negative space was diminished;
C. As I moved the left edge closer in, the compote and fruit on the table was put more off center, therefore making the composition more dynamic. I used the clear plastic ruler to make sure that the edges were square with the drawing. Then I drew those edges and erased any of the lines outside of the edges, so I was sure of what the drawing looked like without any outside distractions. I then measured and cut the hardboard support according to the outside dimensions of the drawing.

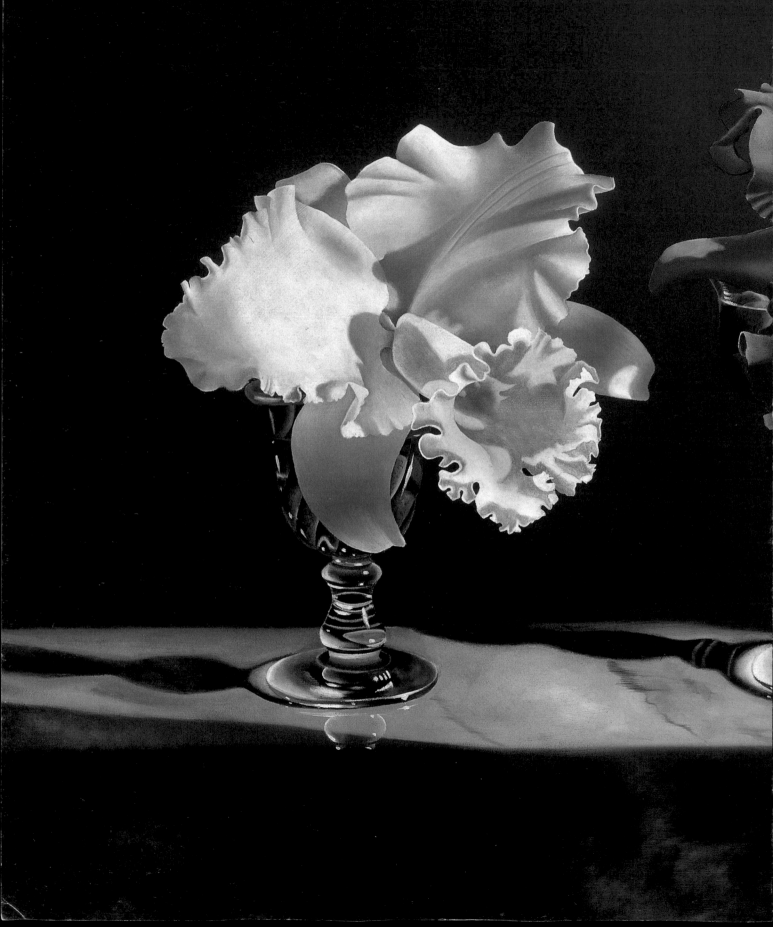

CHAPTER FOUR

Layering for Luminous Effects

Glorious
Oil on hardboard, 18 x 22 inches
Collection of Stephen and Joanne Flynn

I love orchids and think the big cattleya orchids are especially exquisite. I wanted to find the best way to showcase them and experimented until I came up with this idea. I love painting these flowers so much that I decided to grow my own so that I could have even more flowers with which to compose. These two look like they are having a conversation (and maybe even a relationship!).

Basic Underpainting and Glazing

The quality that always intrigues me most in a painting is luminous color. By this I do not necessarily mean bright color, but rather glowing color, color that appears to be lit from within. For example, compare the yellow of a banana skin against the yellow of a traffic light. The yellow of the traffic light appears as glowing color. It is that type of glowing, lit-from-within color that I want to achieve in my paintings.

To achieve luminous color I use a painting technique called "underpainting and glazing." It was and is the technique used by many great master painters of the past and present. However, I have simplified the technique by using a contemporary, fast-drying medium rather than the more complex ones formulated by the Old Masters. Color appears luminous when light passes through the transparent colored glaze, reflects off of the white in the underpainting, and then passes back through the transparent layers of color. So the viewer sees light that has passed *through* the color, not just light reflected *off* of the color.

The underpainting and glazing technique is great not only because of the quality of the color it produces, but also in that it allows the artist to be in control at all times. Since the painting is created in layers, the painting process is broken down into manageable steps. The first layer of paint on the objects (over the toning layer) is the underpainting, which has quite a lot of white in it. The only quality of color addressed in this layer is value: the relative lightness or darkness of a color. In the underpainting, the values can be worked out without concern for color, temperature, or intensity. The next layers are transparent glazes, and it is in these layers that color, temperature, and intensity are considered. Then lastly, in the top layers, the details are painted.

These are the Color Notes that I created for *Sensual Banquet* while looking at the actual objects in the sunlight.

COLOR PALETTE

Ivory Black

Daniel Smith Moonglow

Burnt Umber

Burnt Sienna

Raw Sienna

Yellow Ochre

Grumbacher Thalo Green (Yellow Shade)

French Ultramarine

Alizarin Crimson

Indian Yellow

Transparent Yellow

Titanium White

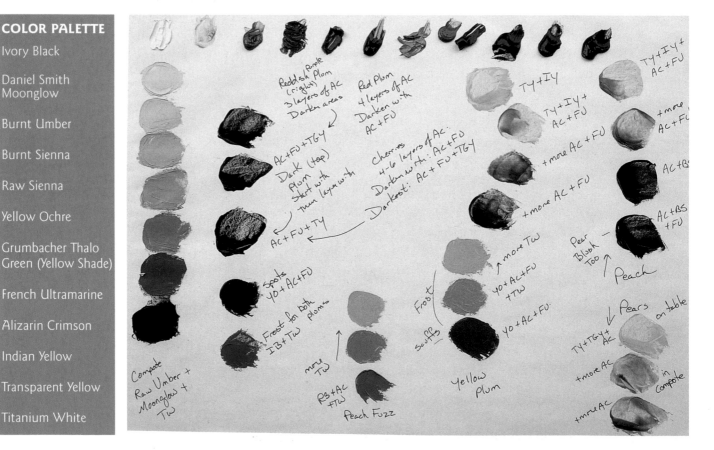

I like to use the underpainting and glazing technique to paint flowers and fruit. These are most often the focal area of my paintings and I want them to be as beautiful and luminous as possible. Contrasting glazed fruits and flowers with objects painted with opaque paint further enhances their luminosity. (Although I do sometimes use glazing to reinforce the darks of opaque-painted objects.)

An underpainting can be painted using any color mixed with white, but the traditional choices are either black and white mixed to a sequence of grays, a neutral brown (either mixed or from a tube) mixed with white, an earth color such as burnt sienna or burnt umber mixed with white, or, for a colored underpainting, the local color of the object mixed with white. 'Grisaille' is the traditional term for a grey or other neutral underpainting. The neutral brown paint mixture itself is called 'verdaccio.'

The following demonstration will present painting with a traditional neutral brown and white underpainting. The forms and light patterns are modeled in the underpainting and then color is added with transparent layers of glaze. It is easy for judgment to be clouded regarding value when our eyes are entertained by color. Using a neutral color for the under-painting allows us to see the forms and light patterns more objectively. Once the value structure is secure, then the colors are added. (Note: The process for drawing the fruit compote was detailed in the previous chapter. The reference photograph for the painting, titled *Sensual Banquet*, is on page 70.)

When painting in layers you need to *think* of objects in terms of layers, especially fruit. A peach has four color layers: the flesh, which influences the color of the skin; the skin itself; the blush; and the fuzz. Therefore, in my Color Notes there are mixtures for all four layers. Plums and grapes are also best painted with color layers, reserving the frost or dew for the final layer. So when you are analyzing the colors for painting be careful to note the colors of each layer. As you look through the step-by-

Once the drawing is transferred over the toning layer, I begin to paint in the background color.

step pictures you will see several stages where the peach and plums look too bright. Yet, once the outer layers are on top of the bright colors, the overall effect is very natural.

I used Raw Sienna mixed with Galkyd for the toning layer. I chose Raw Sienna because it will create a beautiful warm foundation for the background and objects in this painting. The drawing was transferred using transfer paper, which is like carbon paper, but much less messy and available in both white and black. I carefully positioned the drawing on top of the panel, making sure that the vertical axis of the compote was parallel to the sides of the panel and that the tabletop edges were parallel to the lower edge of the panel. I then taped the drawing in place and slipped transfer paper between the drawing and the board. I used a stylus to transfer every line on the drawing. If you cannot find a stylus with a fine tip, then it is best to use a fine-tip ballpoint pen. When transferring the drawing, check under the transfer paper periodically to make sure you are applying enough pressure. Be careful not to use so much pressure that you engrave the lines into the panel.

Sensual Banquet First Layer Palette

Palette of colors for the first layer of paint throughout the painting.

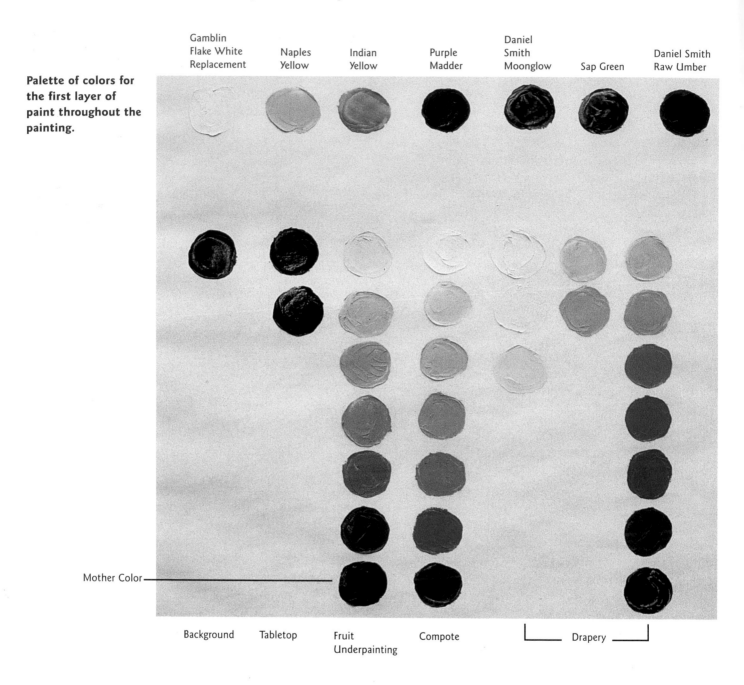

Gamblin Flake White Replacement · Naples Yellow · Indian Yellow · Purple Madder · Daniel Smith Moonglow · Sap Green · Daniel Smith Raw Umber

Mother Color

Background · Tabletop · Fruit Underpainting · Compote · Drapery

For the first layer of the background, I mixed Indian Yellow, Purple Madder, and Sap Green together to make a beautiful transparent brown (this can be substituted with any mix of transparent complementary colors that results in a neutral brown). It is a very versatile brown mixture that can be made into a full range of values. Depending on how the paints are mixed, the color can be a golden brown (with more Indian Yellow), a reddish brown (with more Purple Madder), or a cooler brown (with more Sap Green). Since the background will be quite dark, it's important to establish the value of it very early on so that the values of the underpainting can be judged correctly. For the background I mixed the brown with a little bit more green. I plan to use the same tube colors to mix a brown for

the tabletop, but I plan for that brown to have a bit more red in it. I made the background slightly greener to complement the red.

Using a palette knife, I mixed Galkyd medium into the brown mix to make each brushload of paint equally transparent. Before mixing in the Galkyd, I put a portion of the brown mix in a palette keeper and stored it in my freezer. (I save some of every mix in case I want to use the color again later for touch-ups or repairs.)

I used a small round brush (no. 0) for the tiniest areas and a small (no. 8 or 10) flat brush with a good edge to work around the objects. I used a large 1½-inch flat brush to paint in the larger areas. I worked in 8- to 10-inch segments, first applying the paint and then smoothing it with a large mop brush. When painting large areas, I smooth the paint out as I go rather than wait until the whole area is painted. As they may be visible through the final layer, any brushmarks that remain should all be parallel to each other, either horizontally or vertically. They should all look like they go *behind* the objects, not around them. The edge of the brush often leaves a ridge of paint, so I am always careful to smooth out those areas with a soft clean brush.

For the **TABLETOP,** Indian Yellow, Purple Madder, and Sap Green were mixed to a red-brown. I added more Sap Green for the shadow colors to make them darker and cooler. I painted the tabletop before the fruit to establish, along with the background, the values for the painting. I painted the table so that the brush strokes followed the direction of the wood grain. I mixed medium in with the tabletop colors on the palette so that they would all have the same transparency.

I decided to use a brown underpainting for the **FRUIT** instead of a gray one because the colors of the most important fruits are warm. I mixed the brown from the same tube colors I used for the background, but since I will be layering various colors on top of the underpainting, I made this brown more neutral. Then I added Gamblin Flake White Replacement to the brown to make the lighter

values. It's important to mix at least eight values for the underpainting so to have a whole range available to work with. Save some of the brown Mother Color (transparent color without white mixed into it) for glazing subsequent layers. The values of the fruits were painted to be three to four values lighter than they will be in the finished painting. Each layer of glaze will darken the area, if only slightly, so the underpainting has to accommodate this value change.

The colors of the fruit are red and green, yellow and violet. So there are two sets of complementary colors, and those are the colors to be used throughout the painting. I already used dull green for the background and dull red for the tabletop.

Sometimes objects such as fruit can appear a little bit flat or slightly distorted in a photograph, and if you copy the photograph exactly the painting will have the same shortcomings. The underpainting and the glaze layers can be used to sculpt the forms and create a more accurate rendering. While you are painting, pay special attention to the build-up of paint along the edges of objects. If there is a ridge of paint, either brush it into the object using a *very* soft brush, such as a mop brush, or blot it with a clean piece of newsprint. Do not blot with newspaper as the ink might transfer to the painting, and do not use facial or toilet tissue as they will leave fuzz on the paint surface.

Many fruits, such as peaches, nectarines, apricots, and grapes are more or less just small bags of colored gel and light moves through them as it does through any transparent or semi-transparent object. A high value underpainting will help the color of the fruit achieve that same inner glow.

I decided to use very dull yellows and violets for the **PORCELAIN COMPOTE.** The lightest colors for the compote were mixed using Flake White Replacement and Naples Yellow. The rest of the compote colors were mixed using Gamblin Flake White Replacement, Daniel Smith Moonglow, and Daniel Smith Raw Umber. When mixed together, these last two

HELPFUL HINT

Whenever you are working on a painting, the previous layers of paint should be *really* dry. This way, you can easily remove a mistake in the top, wet layer without disturbing earlier paint applications.

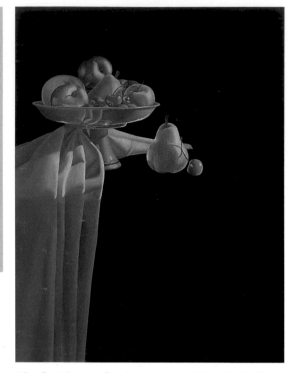

The first layer of paint on everything, including the underpainting of the fruit, compote, drapery, and tabletop.

colors can create a beautiful neutral color that is neither warm nor cool (someone once called it "the color of nothing"—it's there, but completely neutral). For the compote, though, the color is a dull violet.

I paid special attention to the values when painting the compote. A white object is rarely the same white as that which comes directly out of the paint tube, which is why I used the Flake White, Moonglow, and Raw Umber mixture. Plus, when a white object has high shines on it, it must be painted dark enough that the shines show. So to make those high shines really pop, I painted the "white" porcelain to be one value darker than it appeared to be on the object itself and in the photographs. The shines on the compote were painted using Flake White Replacement. The shines will need to be enhanced with another layer of paint later in the painting process.

Reflections also need to be carefully considered. Keep in mind that reflections are usually not as light or bright as the objects themselves. To paint the reflections of the drapery on the

All of the fruit was underpainted using high values of the brown mixture.

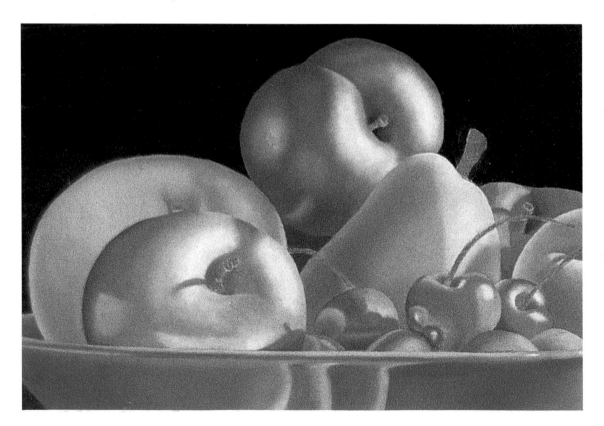

compote, I used my brush to mix some of the colors for the compote into corresponding values of the drapery color mixtures.

I wanted warm colors for the light areas of the DRAPERY and cooler colors for the shadow areas. For the light, warm colors I used Titanium White mixed with Naples Yellow and added a bit of Daniel Smith Raw Umber to dull it. For the cool colors I used the same dull violet colors as for the compote but with a little bit more Moonglow.

For the *Sensual Banquet* first layer palette, the first row of drapery colors are the warm ones and the third row of drapery colors are the cool ones. The colors in between those two rows were made by mixing colors from those two rows together. These in-between colors made it easier to blend between the warm and cool areas of the drapery. I used Titanium White in the drapery mixes because I wanted the whites to be very opaque and bright.

The easiest way to create the illusion of light in a painting is by contrasting values. For the drapery, temperature contrast between the areas of light and shadow was also used. The combination of value and temperature contrasts is very effective for re-creating the brilliance of bright light.

Sometimes this underpainting layer is not completely opaque. Some artists are okay with that look, some are not. It's a personal choice. The Master painters differ in their aesthetic about it, sometimes within the same painting. If too much background is showing through the underpainting, I repaint the underpainting, but that is my preference. A second layer also allows you to adjust the values if they were not quite right the first time.

Once the underpainting is dry, you can begin glazing. Bear in mind that the underpainting has to be *very dry,* or the subsequent layers will mix in with the underpaint and create a muddy mess. Use the transparent Mother Color of the underpainting to darken and adjust the values of the underpainting until the full value structure is developed.

HELPFUL HINT
Remember that each layer of the painting must have some alkyd medium in it. Pour a nickel-sized puddle of medium on your palette, then, tip your brush into the medium before picking up each brushload of paint.

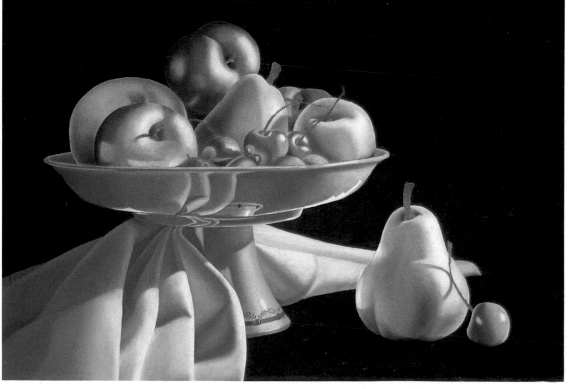

The completed underpainting.

Glazing

I began the glazing process on the fruit. No white is used in the glazing process, so the lightness or darkness of the glaze color is controlled solely by how much medium is added. For a lighter glaze, use more medium and less paint; for a darker glaze, use less medium and more paint. However, for the stability of the painting, some medium *must* be used in all of the layers.

Some of the shadow areas were not quite dark enough, so to make them darker I glazed them with the Mother Color used for the underpainting. Mixed with Galkyd medium, it makes a beautiful brown glaze that is much richer and more luminous than when the color is mixed with white. (The local color glaze of the objects can be used to make the shadow areas darker. I feel that it is easier to make sure the value structure is correct before adding color, but it can be done either way.) To lighten areas, add the appropriate underpainting value to the area and then carefully feather the edges so that the form is continuous and smooth. When the value adjustments are complete, then the painting should look like a tinted black-and-white photograph.

I use white to enhance the light areas and highlights, so I added a thin layer of white to the very lightest areas of the fruit. I want the light areas to be very opaque, so wherever the background was peeking through, I added just a whisper of Flake White Replacement mixed with a very little bit of Galkyd. It's really subtle.

I prefer using sable brushes for glazing. They have a very soft texture, yet enough spring so that they don't "give" too much when pressure is applied to the brush. This soft yet springy combination allows the paint to slide smoothly off of the brush while leaving few brush marks. I brush the paint on the areas I want to be dark, then use a clean, soft flat or mop brush to soften the edges into the underpainting. The transition between where the glaze is and is not should be very delicate. It is far better to have two or three thin layers of glaze than one heavy one. A heavy layer of glaze is much harder to control, and a build-up of thin layers allows for more luminosity.

To reinforce the shadows on the TABLETOP, I added another layer of the brown mix used for shadows in the first layer. Then, for the darkest areas of the shadows, right next to where the shadow touches the object, I added some French Ultramarine to that brown mix to darken and cool it. Using the same brown glaze, I reinforced the darks on the pear and cherry sitting on the tabletop. Notice that the reflection on the left side of the cherry looks lighter. That is because the shadow on the cherry is now darker; the reflection was not lightened at all.

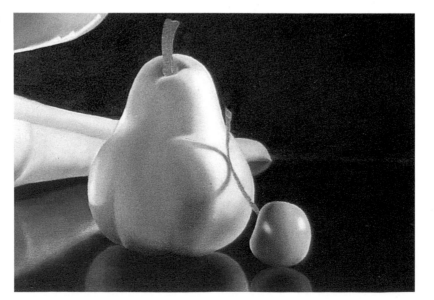

The reflections of the objects on the tabletop were painted using the same underpainting and glazing technique used to paint the fruit. I was careful to softly feather the edges to the inside of the reflections.

Sensual Banquet Glaze Layers Palette

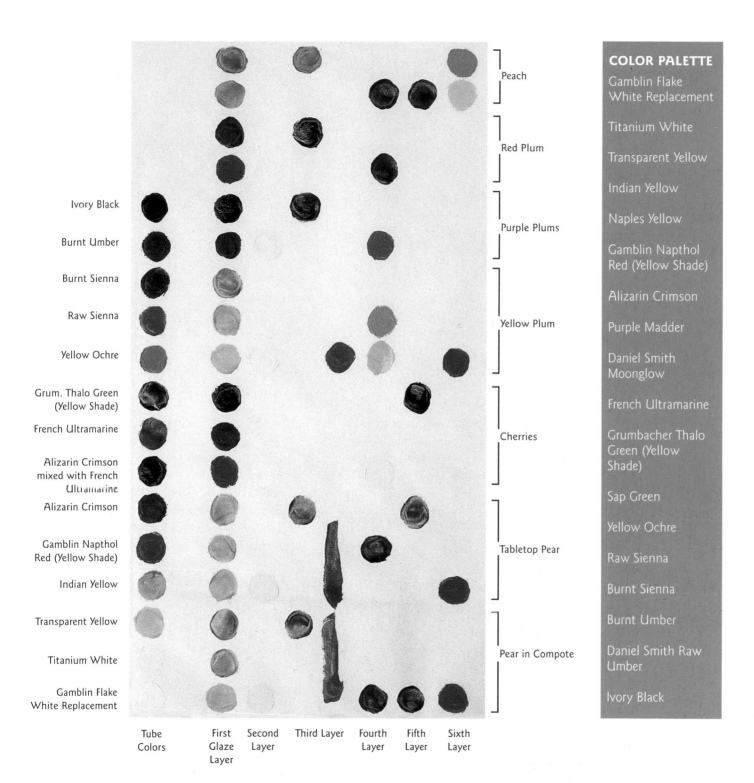

Left-side labels (top to bottom):
Ivory Black
Burnt Umber
Burnt Sienna
Raw Sienna
Yellow Ochre
Grum. Thalo Green (Yellow Shade)
French Ultramarine
Alizarin Crimson mixed with French Ultramarine
Alizarin Crimson
Gamblin Napthol Red (Yellow Shade)
Indian Yellow
Transparent Yellow
Titanium White
Gamblin Flake White Replacement

Right-side bracket labels (top to bottom):
Peach
Red Plum
Purple Plums
Yellow Plum
Cherries
Tabletop Pear
Pear in Compote

Column labels (bottom):
Tube Colors | First Glaze Layer | Second Layer | Third Layer | Fourth Layer | Fifth Layer | Sixth Layer

COLOR PALETTE

Gamblin Flake White Replacement
Titanium White
Transparent Yellow
Indian Yellow
Naples Yellow
Gamblin Napthol Red (Yellow Shade)
Alizarin Crimson
Purple Madder
Daniel Smith Moonglow
French Ultramarine
Grumbacher Thalo Green (Yellow Shade)
Sap Green
Yellow Ochre
Raw Sienna
Burnt Sienna
Burnt Umber
Daniel Smith Raw Umber
Ivory Black

The first layer of glaze. Once the value structure has been finalized, it is time to begin glazing with local color. This is one of my favorite steps in the process because the colors are so beautiful—it's like painting with stained glass!

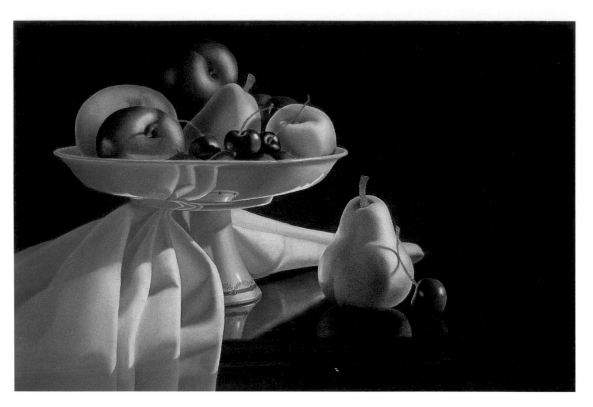

The next step in the painting process is glazing with color. Transparent colors work best for glazing, but opaque colors can be thinned with medium to make them transparent. These glazes won't be quite as luminous as transparent colors, but they work nevertheless. White is never used for glazing because it makes glazes look milky and reduces their luminosity.

The first layer of glaze is usually the local color of each object, as noted on the glaze layers palette. I work some medium into the brush and then work the brush into the color I want to use. I pick up more paint or medium until the paint has the transparency, intensity, and value I desire. (More medium will be necessary for opaque colors than for transparent ones.) Remember that several layers of paint are more luminous and convincing than one or two heavy layers.

Be sure to pay close attention to the lighted and highlighted areas of each object. I laid down glaze color and then used a *soft* piece of paper towel to wipe out the extra pigment. This will leave some color in that area to relate to the rest of the object. Be sure to soften the edges of the glaze as it transitions from the light to dark areas. I often use the same piece of soft paper towel to do this blending as well. If the lighted area dries with too much color on it, I then lighten it in the same manner as I would lighten the underpainting.

Since I do not want to muddy my colors in any way, I use a separate set of brushes for each color sequence. So I have brushes with yellows in them, brushes with reds in them, and so on. It makes for a lot of clean-up at the end of the painting session, but it is worth it to have clean, clear color for glazing.

I used my Color Notes as reference for mixing the glaze colors. Sometimes I follow the notes exactly, while other times, as you will see here, I use them only as a starting point. I decided that the color of the PEAR on the tabletop was not quite right, so I added Indian Yellow to the mix. I mixed more Galkyd with the paint, adding more Galkyd to the brush when I picked up glaze for the light areas. I painted the glaze thinly over the lightest areas of the fruit, and then wiped off the glaze with

a soft paper towel and softened the color into the surrounding areas. I will reinforce the brightest highlights with opaque white in a subsequent layer. I used the same glaze colors to paint the reflection of the pear on the table. The glaze colors used to paint the pear in the compote are the same as those used to paint the one on the table but without the addition of Indian Yellow, making the pear in the compote slightly greener.

Some of the areas on the CHERRIES are an especially warm red. I decided to paint a layer of warm red in those areas, and then let that color show through the subsequent layers. For the overall color of the cherries, I blended Gamblin Napthol Red (Yellow Shade) into Alizarin Crimson. For the darkest areas, I mixed Alizarin Crimson and French Ultramarine. The shines are so bright on the cherries that I carefully painted the glaze around, but not over them. The cherry on the tabletop had a reflection of the pear sitting next to it. I painted the reflection using the same color used to paint the pear in the area closest to the cherry. The reflection of the cherries on the tabletop was glazed using the same colors as for the cherries themselves.

The YELLOW PLUM was glazed with the color mixtures that were in my Color Notes: Transparent Yellow mixed with Indian Yellow, and that color mixed with Alizarin Crimson and French Ultramarine to make three darker mixes.

In the photographs, I noticed red-violet areas on the PURPLE PLUMS that I did not see when I was making the Color Notes. So I decided to make the first layer on the purple plums redder so it would show through and enliven the subsequent layers (which will be the same colors as those in the Color Notes). There are some reflections on the left side of the top plum that I was careful to glaze with Alizarin Crimson.

I decided that Alizarin Crimson was too cool for the light, right side of the RED PLUM, so I used Napthol Red (Yellow Shade) and then blended it into Alizarin Crimson on the darker side.

The Color Notes for the PEACH were too cool, so I decided to use a mix of Indian Yellow and Napthol Red (Yellow Shade). For the darker area of the peach, I used the Indian Yellow and Napthol Red (Yellow Shade) mix, with Alizarin Crimson and French Ultramarine added.

I left the STEMS unpainted until I had finished glazing the fruit, rather than try to paint around them.

After applying the initial layers of glaze, subsequent layers of glaze were added to intensify the local color and to reinforce the darks and shadow areas. If the color had appeared too intense after two or three layers of glaze, I would then have glazed the area again with a complement of the color, or with the color mixed with its complement, or with a duller tube color. While colors that are too bright can be easily dulled in this manner, a color that is too dull is very difficult to brighten. So it's better to start off with a color that is too intense and then dull it rather than the other way around.

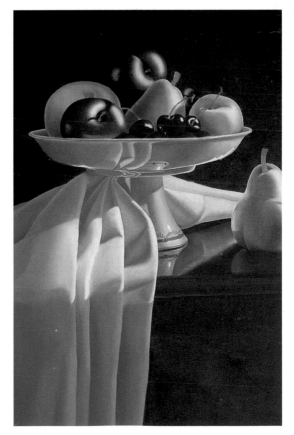

The second layer of glaze. As subsequent layers of glaze were added, the colors of the fruit became more vivid and the contrast between the light and shadow areas became more pronounced.

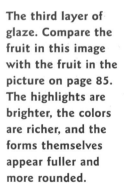

HELPFUL HINT

Don't forget to load a very small amount of medium on your brush before picking up any of the paint for subsequent layers.

The pears, yellow and red plums were glazed a second time using the same colors as for the first layer. For the second layer of glaze on the cherries, I used Alizarin Crimson, with Alizarin Crimson mixed with French Ultramarine for the shadow areas.

The highlights on the shiny fruits were built up using Flake White Replacement mixed with just a whisper of the glaze color used in that area. One of the wonderful qualities about this white is that the edges of a highlighted area can be feathered out to blend into the surrounding areas. It is much easier to blend with Flake White Replacement, or Flake or Lead White, than it is with Titanium White, because the Flake White is more transparent than Titanium White. While you will need to use more layers to build up a really bright white highlight with Flake White, it is worth it.

I began by applying the highlights to the pears, cherries, and plums. I painted the lightest areas first, and then gently feathered the white paint by working a soft, dry mop brush in a circular motion. I repeated this step two or three times to highlight the larger fruit. If

the white paint covered too large of an area, I used a Wipe-Out Tool to wipe up the excess.

In the third layer the highlights got another layer of Flake White Replacement tinted with a very tiny amount of the local color of each fruit. The shadow area of each fruit was darkened with another layer of glaze. To cool and darken the pears and purple plums, I added some French Ultramarine to the dark glaze mixes. In the light areas of the red plum and cherries, the warm Napthol Red (Yellow Shade) underlayer was topped by a cool Alizarin Crimson glaze to make a gorgeous true red.

As much as color brings things to life, so do details. I added spots and scuffs on the pears, plums, and cherries using mixes of Yellow Ochre, Alizarin Crimson, and French Ultramarine. I used a cool white mix of Flake White Replacement, French Ultramarine, Alizarin Crimson, and Thalo Green (Yellow Shade) to add reflections on the cherries. And I painted the blush on the yellow plum using a thin glaze of Napthol Red (Yellow Shade).

The table (except for the top surface) was given another layer of color using the same

The third layer of glaze. Compare the fruit in this image with the fruit in the picture on page 85. The highlights are brighter, the colors are richer, and the forms themselves appear fuller and more rounded.

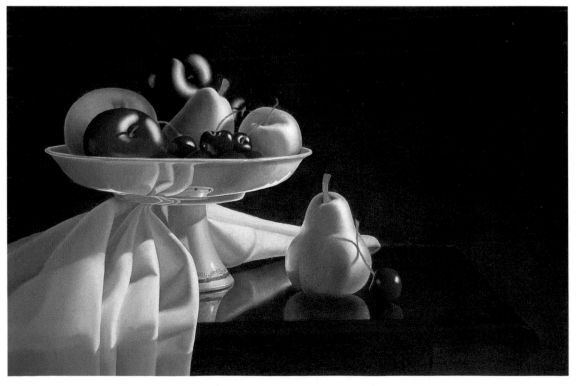

mixes that were used for the first layer. Sometimes I paint a very thin layer of the tabletop color over the reflections to make them really sit "in" the surface of the wood, but this time it wasn't necessary.

The fourth layer of paint included more details and color adjustment. I added the final layer of highlights on the pear and cherry on the tabletop, and the plums in the compote. For the last layer of highlights I used Titanium White mixed with the local color. I used Titanium White instead of Flake White because it is warmer and more opaque than the other whites, so it has a brighter appearance.

I used the mixtures from my Color Notes for the blush on the pears and peach. The blush usually requires two to three layers of glaze to capture the rich color variations. For example, on a peach the blush color varies in color from a warm red-orange to a cool red-violet. The best way to show this variation in color density is by applying several layers of color and modulating the color accordingly.

The colors used to glaze the layers of frost and dew on the yellow and purple plums were also from my Color Notes. It is especially beau-

tiful where the luminous color of the fruit peeks out from under the more opaque frost layer.

A final layer of Alizarin Crimson was painted on the light side of the red plum. I was careful not to add more color to the highlight areas or to the reflection—I didn't want to lose those details.

The stems were painted using Burnt Umber and various brown mixtures created from colors on the palette. I started with a brown made from Yellow Ochre, Alizarin Crimson, and French Ultramarine. I then mixed some of the brown with white for the light areas, and with blue for the darker areas. The actual stems were a variety of different browns, so I varied the browns that I used to paint them. For example, some of the stem browns have more Yellow Ochre in the mix. Notice that I left the stems that extend into the background unpainted. It is easier to paint these in after the background is completed, rather than try to paint the background around them.

Galkyd medium was used in all of the paint for stability as well as to accelerate the drying time.

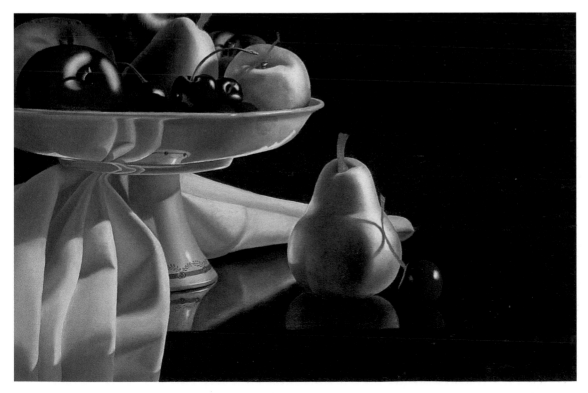

In the fourth layer, I adjust the colors, add more details, and finalize the highlights. Note how crisp the highlights now appear, contrasted with the deep coloration of the fruit.

In the fifth layer of paint, I used Titanium White to reinforce the highlights on the compote. To even out the surface of the tabletop, I applied another layer of color mixed with Galkyd. The shadows of the cherry and pear on the tabletop were emphasized using their dark mixtures. I added another layer to the blush on the pears and two more layers to the blush on the peach. I painted the background with the same colors as used for the first layer (of course mixed with medium). And then using various brown mixtures from the colors on my palette, I painted the remaining stems.

To finish, I completed the reflection of the pear on the compote using the glaze colors for the pear and stem. The blush on the pears and yellow plum didn't seem bright enough, so I brushed on some Gamblin Napthol Red (Yellow Shade) to perk them up. (The brush was lightly tipped in Galkyd before picking up the paint.) The fuzz on the peach was lightly tapped on using a small fuzzy brush (a ¼-inch mop brush). I used the colors from my Color Notes: Raw Sienna mixed with Alizarin Crimson and Flake White Replacement. I tipped the brush in Galkyd and then lightly wiped it on a paper towel before picking up the paint. Notice that the "fuzz" really softens the appearance of the peach colors and that it slightly overlaps the background.

In the fifth layer of paint, I reinforced the highlights and shadows, and deepened the blush of the fruit. I added a final layer of color to smooth the surface of the table and painted in the background.

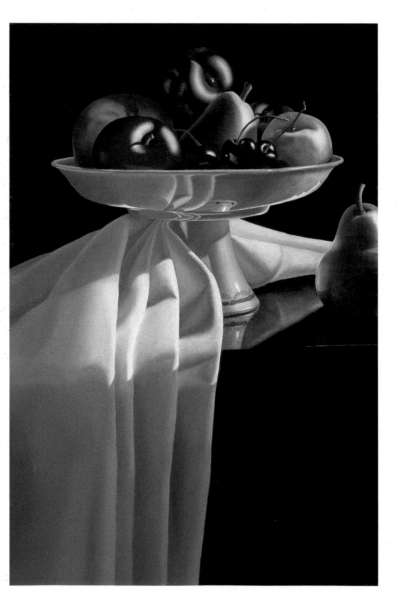

Opposite:
Sensual Banquet
**Oil on hardboard,
29 x 22 inches**

The completed painting with the last few details done.

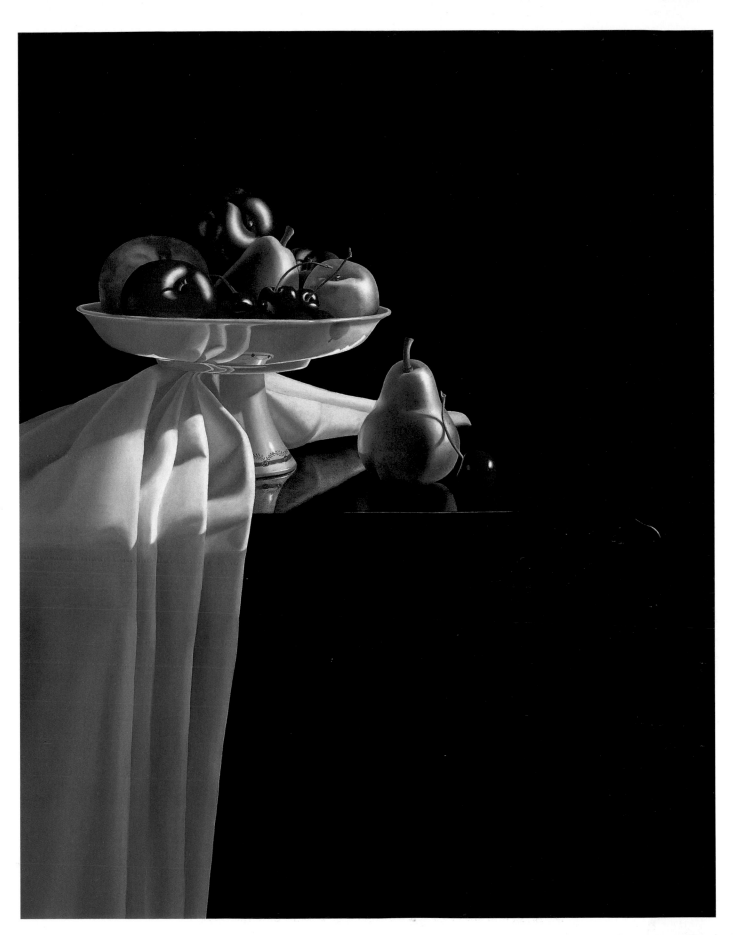

Colored Underpainting

Colored underpaintings were used historically to showcase the incredible beauty of the paint colors. The underpainting was sometimes a flat shape of color upon which transparent glazes were painted to model the forms. Other times, the colored underpainting was fully modeled, yet much lighter than what was desired for the final effect. I prefer the second technique because it establishes both form and the illusion of light very early in the painting process. Starting with only a flat shape of color makes it more difficult to create the desired illusions.

The colors of fruits and flowers are often brilliant and full of intensity. And in oil paint, so many of those exquisite colors are only available as transparent colors. While underpainting and glazing is an excellent approach to re-creating those magnificent colors, a brown underpainting is not always the best choice for interpreting those colors into paint. On the other hand, a colored underpainting uses the local colors of the objects mixed with white. The objects are then glazed using colors at their full intensity, not dulled with any other colors or even with white. The end result is just wonderful, brilliant, luminous color!

The **BACKGROUND** color is a mix of Cadmium Yellow Pale, Ivory Black, and Titanium White. I used the opaque Cadmium Yellow Pale rather than the Transparent Yellow because I wanted the background to be as opaque as possible. I use Titanium White rather than any other white in the color mixes for background areas because in a large area it blends so much more easily than any of the other white choices. As long as a significant amount of alkyd medium is mixed with it, a stable painting can be created. First, I mixed the Cadmium Yellow Pale and Ivory black to a very dull green and then added the Titanium White. The darkest five values on the palette, to the right of the toning layer, are the background colors. The five values to the right of the background colors are the same color, but with more white added. These are the colors I used to paint the glass. The background and marble were painted using Liquin in the paint so that the painting will be stable and to accelerate drying time.

The **MARBLE** underpainting is a mix of Grumbacher Thalo Green (Yellow Shade), Transparent Yellow, Ivory Black, and Titanium White (row 2 on the palette). I paint marble

COLOR PALETTE		
Winsor & Newton Underpainting White	Permanent Rose	Grumbacher Thalo Green (Yellow Shade)
Titanium White*	Daniel Smith Autograph Bordeaux	Ivory Black
Grumbacher Naples Yellow Hue	Alizarin Crimson	Orange Mix: Diarylide Yellow with Transparent Orange
Cadmium Yellow Pale	French Ultramarine	
Transparent Yellow	Viridian*	Violet Mix: Alizarin Crimson with French Ultramarine
Indian Yellow	Grumbacher Chrome Oxide Green	*Viridian and Titanium White are not on the picture of the palette.
Grumbacher Diarylide Yellow	Sap Green	
Gamblin Transparent Orange		

Garden Rainbow Palette

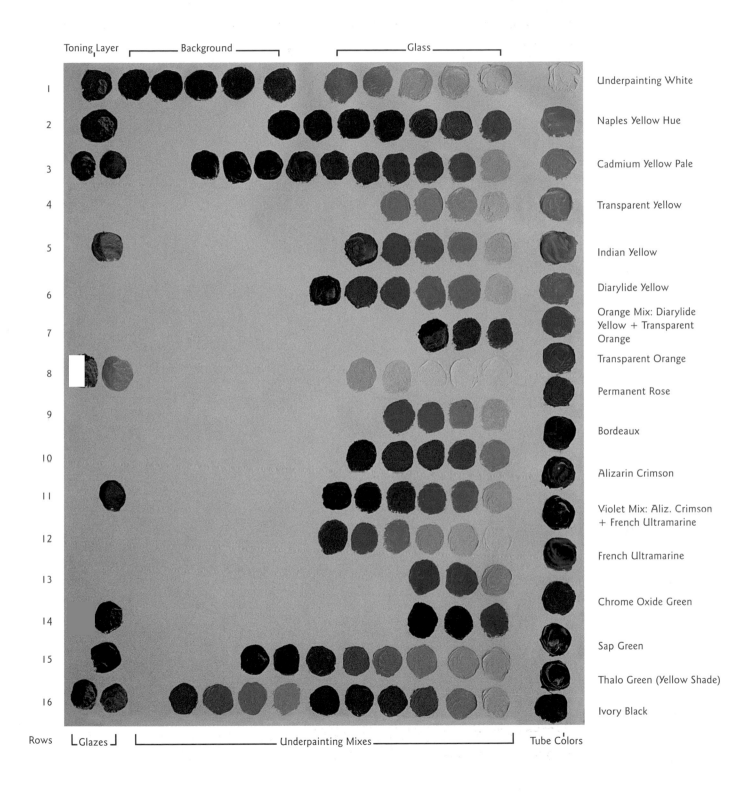

Toning Layer · Background · Glass

Rows		Tube Colors
1		Underpainting White
2		Naples Yellow Hue
3		Cadmium Yellow Pale
4		Transparent Yellow
5		Indian Yellow
6		Diarylide Yellow
7		Orange Mix: Diarylide Yellow + Transparent Orange
8		Transparent Orange
9		Permanent Rose
10		Bordeaux
11		Alizarin Crimson
12		Violet Mix: Aliz. Crimson + French Ultramarine
13		French Ultramarine
14		Chrome Oxide Green
15		Sap Green
16		Thalo Green (Yellow Shade)
		Ivory Black

Rows ⌊Glazes⌋ · Underpainting Mixes · Tube Colors

The toning layer, or *imprimatura*, is a mix of Viridian, Sap Green, and Ivory Black thinned with Liquin and Sansodor (the Winsor & Newton solvent). Though I planned on using Thalo Green (Yellow Shade) in the color mixes for the marble, I chose to use Viridian in this layer because it dries much more quickly.

The initial layers of paint included the background and marble underpainting. Notice how softly I have blended the background values so they don't appear to be stripes. For more tips on successful blending, see Blending, page 40.

by laying the colors on in random blotches and then gently blending the blotches together. I use a small round brush and the lightest colors to paint in the veins. I then soften the veins with a large, soft mop brush, moving the brush in the direction of the front edge of the marble.

Once the background was really dry, I undercoated the iris shapes with Underpainting White mixed with a little bit of Liquin. This layer should be as opaque as possible so the background color will not influence the color of the flowers—I wanted the colors of the irises to be very clear and not muddied by the background color peeking through. First, I used white transfer paper to transfer just the outline of the flowers to the dry background. Then I carefully painted inside the outlines with Underpainting White,

being sure to soften any ridges with a soft mop brush. This layer, and the subsequent layers, should be as smooth as possible. The glazing layer will reveal any surface irregularities, creating a visual distraction in the final painting. If I notice any mistakes in the drawing that I would like to correct in the painting, I simply cover the white with some of the extra background color that I stored in my freezer.

The paint used for the underpaintings had just a small amount of Liquin added to it as it was brushed on. Before loading the brush with color, I would just barely tip the brush in the Liquin. As white dulls color, the colors of the underpainting appear as watered down versions of the colors I ultimately wanted. Glazing over the colored underpainting will really brighten these colors and bring them to life.

The Flowers

For the lighter areas of the PEACH PETALS (row 4 on the palette), I used the Orange Mix (Diarylide Yellow and Transparent Orange) and Underpainting White. The colors in rows 5 and 6 of the palette were used to paint the shaded areas of the peach petals. For the colors in row 5, I added some of the Violet Mix (Alizarin Crimson and French Ultramarine) into the Orange Mix to create a dull orange. This Orange-Violet Mix became the Mother Color. I then lightened the Mother Color with Underpainting White. The colors in row 6 are the same combination of the Violet Mix and Orange Mix as in row 5, but this time with a bit more of the Violet Mix added.

The colors in row 7 of the palette were mixed using the Orange Mix, Violet Mix, and a bit of Alizarin Crimson to create the Mother Color and then lightened with Underpainting White. I used these colors to paint the areas on the peach petals that had reflections of the burgundy petals.

The colors for the BURGUNDY PETALS are in row 3 of the palette. I started by mixing the sixth color from the top: Alizarin Crimson and Underpainting White. I then lightened that mixture with white to make the two color steps above it. For the three lightest mixtures, I not only lightened with Underpainting White, but also added some Permanent Rose to brighten the mixtures. To make the darker values, I added French Ultramarine to Alizarin Crimson. The Ultramarine not only darkened the color, but cooled it as well.

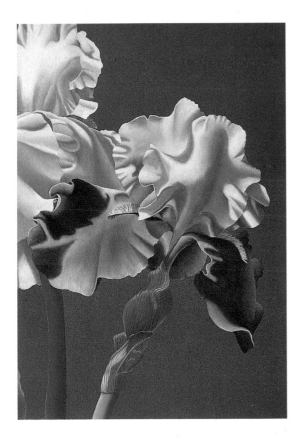

The underpainting of the iris with the peach and burgundy petals. I could have used Transparent Yellow to create the colors for the underpainting of the YELLOW IRIS, but since I already had Cadmium Yellow Pale on my palette, and as I wanted the underpainting to be opaque, I used the Cadmium Yellow Pale mixed with Underpainting White (row 8 on the palette). For the colors in row 9 of the palette, I mixed Cadmium Yellow Pale with the Violet Mix and then lightened with Underpainting White. I used the same combination to create the colors in row 10, but added a bit more of the Violet Mix to the Mother Color (Cadmium Yellow Pale).

HELPFUL HINT
Do not mix white into all of the Mother Color. Save some of the orange Mother Color to be used as a transparent glaze.

Whites are always interesting to mix because they can be influenced to go in so many different directions. Usually my preference is to create the white in a color family that relates to the rest of the painting. Since the WHITE IRIS is set away from the primary focal area, I decided to mix the whites using a green influence to go with the green background. Still, I didn't want the white to be too similar to the background, so I used a cooler green (Thalo Green [Yellow Shade] and Underpainting White) mixed with Alizarin Crimson. For the areas in the light, I used Underpainting White warmed with a small amount of Naples Yellow Hue (row 12 on the palette).

The colors for the part of the red-violet edge that was in the light were a mix of Bordeaux and Titanium White. For the shadow parts of the edges (row 14 on the palette), I dulled and darkened the Bordeaux with Chrome Green Oxide and then added Underpainting White to create the lighter values of the shadow areas.

For each petal, I first painted the values of the white area, blended those together, and then painted the light and shadow areas of the red-violet edge. Next, I blended the edge colors together, and then used a very small mop brush (about ⅛ inch) to lightly drag the red-violet into the white area. Before each stroke, I wiped the mop brush off on a paper towel so I would not accidentally carry the white into the violet edge.

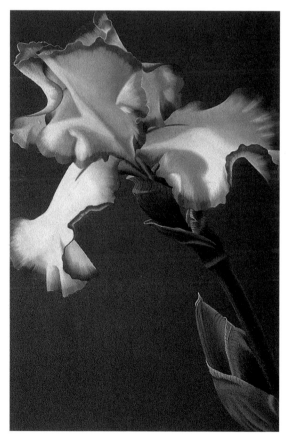

The white iris petals with red-violet edges. Note how I use the brushwork to mimic the way the colors blend on the actual petals.

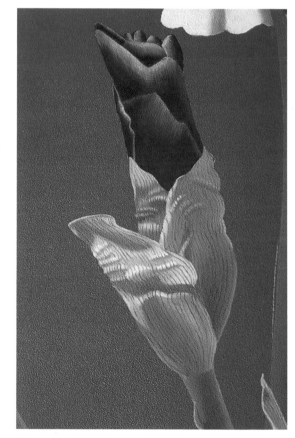

To underpaint the BUD, I lightened the Violet Mix with Underpainting White (row 11 on the palette).

The Stems, Leaves, and Spathes

For the browns for the SPATHES (the papery parts of the stem and leaves), I mixed a brown from Alizarin Crimson and Sap Green (row 15 on the palette), and then lightened the mix with white. The mixture makes a wonderful, rich, and versatile brown that can be neutral—that is, neither red nor green—or it can lean toward one or the other. Here, I chose to lean the brown a little bit toward green because that best matched the original color and it made it a bit easier to blend the brown in with the stem colors. For the lightest two values, I mixed in some Cadmium Yellow Pale to warm the brown

and to make the lighter areas visually stronger. Since there are only small areas that are in the light, the highlights need to be as strong as possible.

The STEM colors (row 16 on the palette) were mixed using Cadmium Yellow Pale, French Ultramarine, and Underpainting White. There are two sets of greens. The last set has a little bit more Cadmium Yellow Pale in it to make the colors warmer. I used these warmer greens in the lower parts of the stems. There are some flowers, for example irises and tulips, whose stems are lighter and warmer at the bottom than others, because as they grow they are shrouded in leaves and shade.

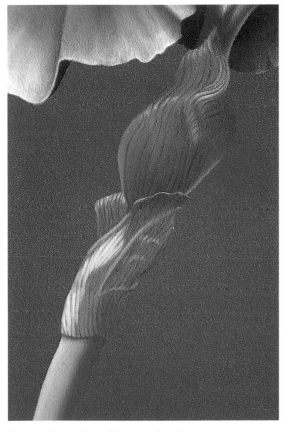

Stem of peach and burgundy iris.

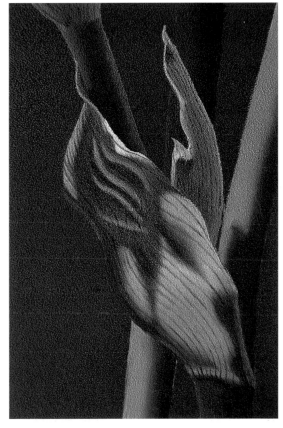

Stem of the bud.

HELPFUL HINT

When you paint stems appearing below a water line, take special care to note the shadow of the water as it is cast on the stems. While there aren't any shadows on the stems in this painting, you can see an example of this in the painting *Illumination*, on page 54.

Glazing

I painted two layers of glaze over the MARBLE underpainting. I used a mix of Thalo Green (Yellow Shade), Transparent Yellow, and Ivory Black and added Liquin to make it more fluid and transparent, for stability, and to accelerate drying time. The layers of glaze help give the painted marble the translucent appearance of real marble. It also makes the veining appear to be within the marble and not just sitting on top of it. The back edge of the marble was glazed so that the soft edge between the background and marble ledge was maintained. I used a heavier glaze toward the back edge of the marble to make it appear to recede. I also applied a heavier layer of glaze toward the bottom of the front edge of the marble because it is in shadow. I very carefully painted a thin layer of Titanium White on the center of the front edge to make that edge appear to advance. I blended the edges of this highlight just a bit, so the reflection looks as if it is a part of the marble and not just sitting *on* it. Once the foot of the vase is painted, I planned to go back and reinforce some of the reflections of the vase in the marble.

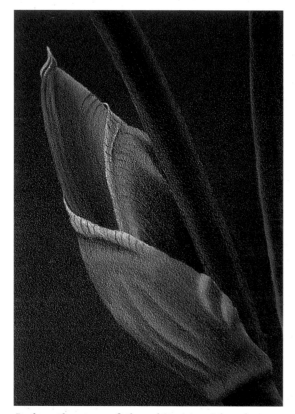

Bud on the stem of the white iris with red-violet edges.

Stem of the white iris.

HELPFUL HINT

I used separate brushes for each color so that the colors would remain clear, bright, and unmuddied. Use alkyd medium to clean brushes *during* your painting session. Squeeze as much paint out of your brush as possible with a paper towel, then load the brush with the drying medium and wipe it again on the paper towel. Repeat this until the brush is free of any pigment. (Be patient, it might take a few times.) Do not use brush cleaner or turpentine as they are solvents and can potentially dissolve your underpainting.

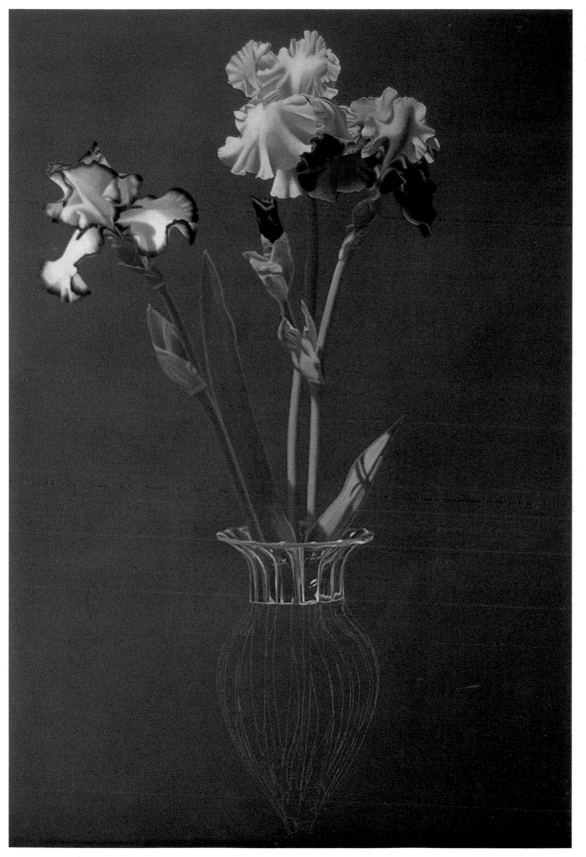

Overall painting with first layer of glazing on the flowers and bud.

For the **PEACH PETALS** I used the Mother Color on row 5 of the palette (the one made by combining the Orange Mix and the Violet Mix). Remember the Mother Color does not have any white in it, so it is transparent and therefore good for glazing. I brush-mixed that color with some Liquin medium to make it lighter and more transparent. (Remember: Add more medium to lighten a glaze; add less medium to make it darker.)

For the **BURGUNDY PETALS** I used Alizarin Crimson for the light and medium areas and then mixed it with some French Ultramarine for the darkest areas. To keep the lightest areas from getting too dark too soon, I painted on the Alizarin Crimson glaze and then lightly wiped some of it off with a folded, soft paper towel. Sometimes, lightening a glaze color with medium makes the glaze too runny, so I prefer to use the wipe-off method instead.

HELPFUL HINT

I use folded, soft paper towels a lot in the glazing process. First, I use towels to *gently* rub off some of the glaze in the lightest areas. Then, I use the same folded paper towel to blend the lightest areas into surrounding areas.

First layer of glaze on the yellow iris. I used Transparent Yellow mixed with Indian Yellow as a glaze in the light and medium value areas. For the darker areas, I used the darkest, dullest yellow from the underpainting of the peach petals (row 6 on the palette). (I thought the yellow iris was just a little bit green and chose a glaze with some red in it to neutralize the green.) I used Alizarin Crimson to glaze over all of the bud to unite it with the red violet areas of the other flowers.

The first layer of glaze on the red-violet edges of the white iris. I mixed Bordeaux with French Ultramarine to create an exquisite red-violet for the light and medium areas of the flower edges. I used the same mix, but with more French Ultramarine for the shadow areas. I brushed the paint on toward the edge with a small flat brush, and then used my smallest mop brush to softly drag some of the red-violet mix toward the white areas, as I did with the underpainting.

The Vase

The transparent glass of the vase was painted using the background colors that I saved, as well as the lightest flower and stem colors mixed with Underpainting White to create several light values (right part of row 1 on the palette) and stem colors.

Painting clear glass is one of my very favorite illusions, but it can be tricky. It is absolutely necessary to paint what the glass *really* looks like rather than what I *think* the glass looks like. I usually paint glass upside down, or from the side, as I did here. If I change the orientation slightly, it is easier for me to see and paint the abstract shapes as they actually appear in the photograph. Otherwise, I tend to try to "correct" the image as I believe it should appear. (A similar trick is looking at a painting in a mirror in order to find mistakes.) When you take something out if its usual orientation, or the way your brain is accustomed to seeing it, then you see it in a new way (even though it is something your eyes are familiar with seeing). As I work on the drawing and as I refine the drawing in the painting process, I adjust the shapes a bit to make them more cohesive and elegant, or I simplify or break up shapes that seem too large or clumsy. Don't be a slave to the photograph. Still, with that said, I rely heavily on the photograph to give me clues about values and edges. In glass, there are all kinds of edges, from well defined, crisp edges to areas that blend indecipherably from one value or color to another. So really the illusion of clear glass comes down to painting abstract shapes with varying hardness and softness of edges.

I especially love painting clear glass that is segmented like this because each segment is its own abstract painting. Notice that I have softened at least just a little bit between each segment so that they appear to belong together as a whole. The only completely hard edges are between one complete object and another. The parts of the whole object need to be cohesive.

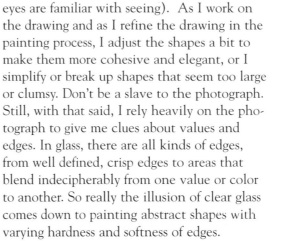

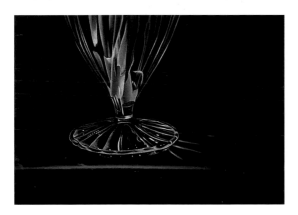

I painted the foot of the vase with the lightened background colors from the upper parts of the vase and the marble glaze color.

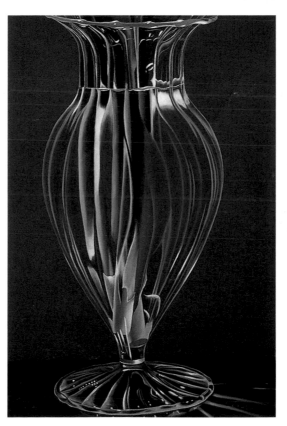

The completed vase. Deepening the darks of the stems in the vase created more contrast for the highlights to pop off of. I reinforced the brightest highlights throughout the glass with Titanium White, because it is the most opaque white. Now the whites have the sparkle of glass in bright light. I used the background colors to clean up some of the edges of the glass.

HELPFUL HINT

Remember that medium should be added to make all of the colors more transparent and fluid, as well as for the stability of the painting.

Finishing Layers

For the second layer of glaze on the yellow iris, I used the same glaze that I used for the first layer, but placed it only in the darkest areas of the shadows to give them more depth both of form and color.

I was very happy with the glaze color on the edge of the white iris. I did not want to darken it any more in the dark areas because this iris is a bit away from the focal area of the other two irises and I did not want to attract any more attention to it by increasing its value range or intensity.

I used the same color to glaze the peach iris petals as for the first glaze layer, but kept it out of the lightest areas. I used another layer of Alizarin Crimson with medium over the burgundy petals; however, I did not use any of the Alizarin Crimson mixed with French Ultramarine because the dark areas were dark enough. (I prefer to use several layers of a color rather than one or two heavy layers. The color is easier to control this way, and it is ultimately more luminous.)

The color will really gain depth with the third layer of Alizarin Crimson. Alizarin Crimson is such a gorgeous color, but it takes several layers for it to really show its beauty.

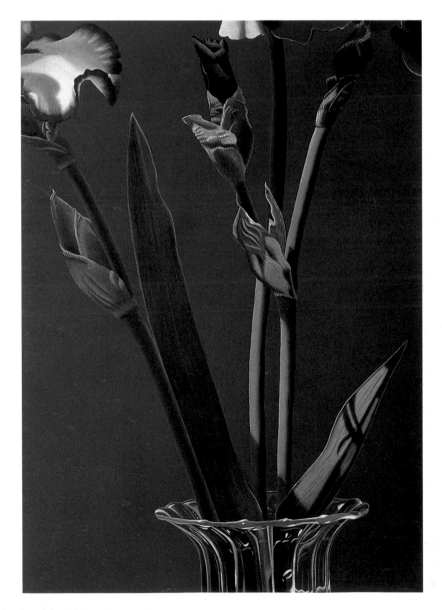

The colors of the flowers were so luminous and rich that in comparison the stems and papery parts were rather chalky and dull. I felt that they needed more value contrast, so I decided to glaze them as well. For the darks on the papery parts (spathes), I used the darkest brown in row 15 on the palette, which was mixed using Alizarin Crimson and Sap Green. It is still transparent because it has no white in it. I used a *very* light glaze of it over all the spathes and used it more heavily to reinforce some of the shadows.

The darkest areas of the stems were glazed using a mix of Sap Green and French Ultramarine; the medium and lighter areas of the stems have a very light glaze of Sap Green. I didn't want to darken them, just warm them a bit and eliminate the chalky look.

Adding the stem glazes in the vase was a little bit tricky. Wherever there were the lights and highlights of the vase, I glazed right over those. After I blended and softened the glaze colors, I then used the Wipe-Out Tool to remove the green from the highlight areas. Wherever I left a ridge of paint with the Wipe-Out Tool I used a mop brush to soften it out.

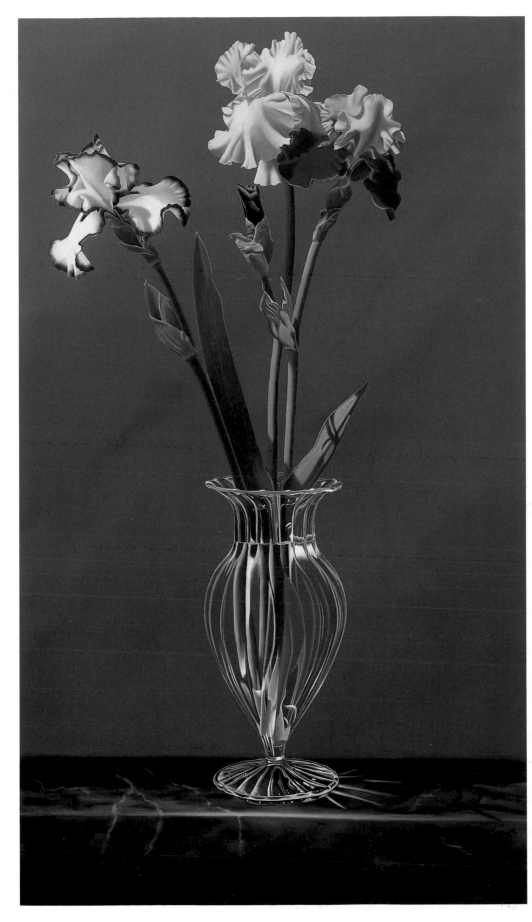

Garden Rainbow
**Oil on hardboard,
50 x 26 inches.
Collection of John
and Thaissa
Klimavicz**

**The completed
painting.**

Clear and Bright Yellows

Of all of the full intensity colors on the color wheel, yellow is the most luminous. That is because it is the lightest and lets the largest amount of light pass through it. But, because of color chemistry, yellow can be a difficult color to work with. One of the best ways to dull and darken colors is to add their complement. Unfortunately, though, the most likely result of mixing yellow and violet is a greenish yellow. Yellows can be successfully painted using either a brown underpainting or a colored underpainting. Since the dulling and darkening is done in the underpainting step, the yellow is not physically mixed with another color, making it is less likely to turn green. In the following example, *Golden Glory,* the brown underpainting works as a colored underpainting, because the brown is essentially a dull yellow.

Dark blue is such a beautiful contrast for yellows, so I used a BLUE DRAPERY with these end of the season sunflowers. Cobalt Blue is exquisite but rather costly, and it is considered to be semi-transparent, which means it is neither especially opaque nor particularly transparent. So, it can be troublesome as an underpainting color, and not all that great as a glaze. I discovered that Winsor Blue (or any

phthalocyanine blue) mixed with Ivory Black and white creates the same color as Cobalt Blue, and it is very opaque. Plus the blue mixed with the black makes a wonderful transparent dark blue, much darker than that which can be achieved with the more costly Cobalt Blue. The background was first painted with two layers using a mix of Winsor Blue and Ivory Black (without the white) with Galkyd.

The drapery was painted using a colored underpainting and then glazed with transparent layers of Winsor Blue mixed with Ivory Black. The blues of the drapery were painted using mixtures of Winsor Blue, Ivory Black, and Titanium White. I tipped the brush in Galkyd medium before picking up each brushload of paint. I painted the drapery two to three values lighter than I want it to be after it is glazed.

It is much easier to finish painting and glazing the drapery and *then* paint the sunflowers on top of it, than it is to paint the flowers and then try to paint the drapery around them. If you paint the drapery first, the glaze layers will be smoother and the drapery will appear to "go behind" the flowers rather than just bump up to them.

Phthalocyanine Blue is such an intense, deep blue. I love using it for transparent blue backgrounds because it gives me a chance to use it straight from the tube. Winsor Blue is the name of Winsor & Newton's phthalocyanine blue. I chose to use the green shade of the blue mixed with Galkyd medium.

Golden Glory Palette

Tube Colors*

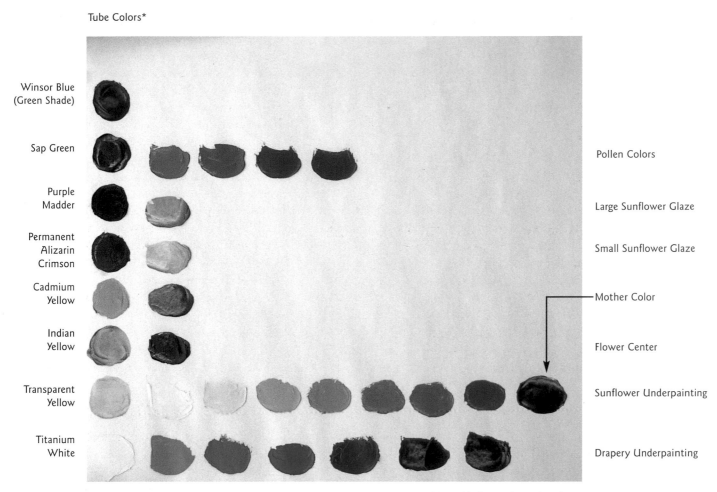

Winsor Blue (Green Shade)

Sap Green — Pollen Colors

Purple Madder — Large Sunflower Glaze

Permanent Alizarin Crimson — Small Sunflower Glaze

Cadmium Yellow — Mother Color

Indian Yellow — Flower Center

Transparent Yellow — Sunflower Underpainting

Titanium White — Drapery Underpainting

*Ivory Black not shown in palette

I used Winsor Blue (Green Shade) mixed with Galkyd to glaze the drapery. Less pigment was used in the light areas and more was used in the darker areas. Since this blue is very intense I prefer to start with a thin layer of pigment and then layer over it slowly and carefully. It would be easy to lose the light areas of the drapery with one too many layers of glaze.

COLOR PALETTE

Ivory Black	Permanent Alizarin Crimson
Winsor Blue (Green Shade)	Cadmium Yellow
Sap Green	Indian Yellow
Purple Madder	Transparent Yellow
	Titanium White

For the underpainting of the SUNFLOWERS, I mixed a brown using Indian Yellow, Purple Madder, and Sap Green. The brown is rather warm and golden to support the intense yellow color of the glaze layers. The brown was then mixed with Titanium White to create a series of values.

On the palette you will notice that the less white the brown has in it, the more transparent it is. When the darks are this transparent it is difficult to keep them as dark as desired once they are blended with adjacent colors that have a lot of white in them. So understand that the darks can be painted in, but will need to be reinforced in the glazing stages where they will not be mixed with white.

The center of the flower was filled in using the brown Mother Color of the sunflower underpainting adjusted with Purple Madder and Sap Green to make it darker and less

warm. Brown this dark is usually quite transparent so will take two or three layers to cover the white of the undercoat.

For the first layer of glaze on the sunflowers, I mixed the Mother Color from the underpainting with more Indian Yellow to make it more of a dull yellow. I used this dull yellow to warm and slightly darken some of the shadow areas.

I wanted the yellows of the two sunflowers to be different, so I decided to make one a cooler yellow and the other one a warmer yellow. The small sunflower was glazed with Transparent Yellow mixed with a very little bit of Indian Yellow. I used Galkyd as a medium. The Transparent Yellow alone was just a little bit too cool and lemony, so I added the Indian Yellow to warm it up just a bit. Indian Yellow is a lot more intense than Transparent Yellow, so I had to be careful to keep this yellow cool and not let the Indian Yellow take

I am very happy with the value structure and the color that was established in the underpainting of the drapery, so it is difficult to consider glazing over it. Yet, having done this before, I know that after a couple of layers of glaze the color will be incredible.

I wanted a bit more richness in the blue drapery, so I added another glaze layer of Winsor Blue (Green Shade) mixed with Galkyd. The shapes of the sunflowers were undercoated with Titanium White.

The first layer of glaze on the sunflowers.

over. I used a small piece of soft, folded paper towel to *gently* wipe some of the glaze out of the lightest areas.

The larger sunflower was glazed with Indian Yellow mixed with Galkyd. I used paper towel to lift some glaze from the lightest areas. These yellows are so luminous that they can be painted in just one or two layers.

The same brown mix was used as in the previous layer to paint the upright stalks in the flower center. Highlights on the STAMEN (which sit atop the stalks) were added using various mixtures of Cadmium Yellow, Winsor Blue (Green Shade), and Permanent Alizarin Crimson. The greens for the STEMS were mixed using Cadmium Yellow, Winsor Blue (Green Shade), and I added Permanent Alizarin Crimson to dull the green a bit.

A second layer of glaze was painted onto each of the sunflowers to deepen and enrich the color. I was careful to keep the temperature difference in the color of the two flowers. I used a soft paper towel to remove glaze from the lightest areas of each petal, so that even in this last layer of glaze the texture of each petal was enhanced.

Pure, intense yellow is a joy to glaze with because it is so luminous. Notice how the yellow of the sunflower on the right is warmer than the yellow of the sunflower on the left.

Golden Glory
**Oil on hardboard,
13 x 17 inches**

The completed painting.

Transparent Under, Opaque Over

Historically, flower painters grew many of their own flowers. While flower markets have been around for centuries, and today's florists have a vast selection of flowers from which to choose, there is still even greater satisfaction in working from homegrown flowers. Once I saw the vast possibilities at my local garden center and in mail-order catalogs, I was determined to grow my own. And the delight that I feel from painting one of my own is so wonderful. There is a myth that roses are hard to grow, yet any effort is more than made up for in their beauty and perfume.

The transparent under, opaque over technique used to create the painting *Summer Magic* is different than that of the previous paintings. After the white undercoating for the flowers is dry, I blocked in the color with a layer of transparent color. Then, when the transparent color was dry, I painted the flowers using opaque color for the light and middle values and more transparent color for the darker areas.

This technique is similar to the technique of Rachel Ruysch and the other Dutch flower painters of the late 17th and early 18th centuries discussed in the introduction. They would block in the colors of the flowers, using opaque colors so that the painting would look like large colorful puzzle pieces. I prefer using a transparent color because it results in more luminosity, even when more opaque colors are placed on top of it. Also, while the historical paintings usually had dark backgrounds, I thought that the colors of these roses would look best on a middle value of a dull version of their complement, green.

Summer Magic Greens Palette

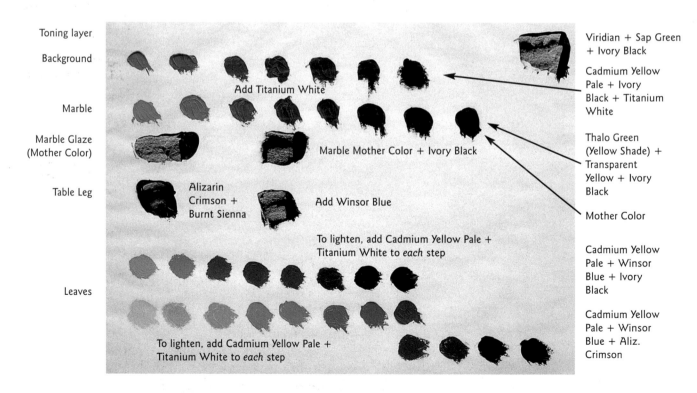

Toning layer
Background

Marble

Marble Glaze
(Mother Color)

Table Leg

Leaves

Add Titanium White

Marble Mother Color + Ivory Black

Alizarin
Crimson +
Burnt Sienna

Add Winsor Blue

To lighten, add Cadmium Yellow Pale +
Titanium White to *each* step

To lighten, add Cadmium Yellow Pale +
Titanium White to *each* step

Viridian + Sap Green
+ Ivory Black

Cadmium Yellow
Pale + Ivory
Black + Titanium
White

Thalo Green
(Yellow Shade) +
Transparent
Yellow + Ivory
Black

Mother Color

Cadmium Yellow
Pale + Winsor
Blue + Ivory
Black

Cadmium Yellow
Pale + Winsor
Blue + Aliz.
Crimson

The toning layer, background color, and leaf colors for *Summer Magic* are on this palette.

Summer Magic Flower Palette

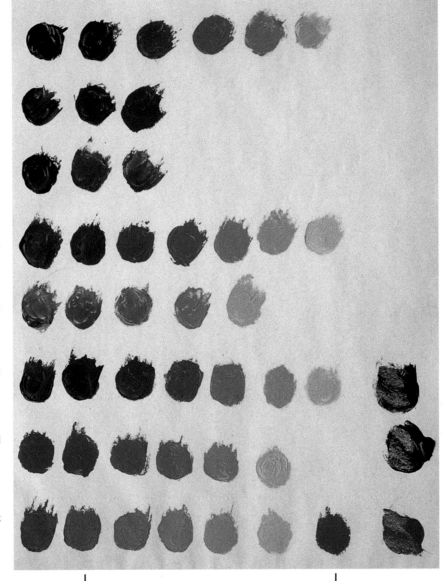

The colors used in the flowers and vase in the painting *Summer Magic* are on this palette.

Sennelier Alizarin Crimson + Burnt Sienna + Winsor Blue

Sennelier Aliz. Crimson + Burnt Sienna + Cadmium Red

Sennelier Aliz. Crimson + Burnt Sienna

Sennelier Aliz. Crimson + Burnt Sienna

Rose Dore + Transparent Yellow Oxide

Sennelier Aliz. Crimson

Cadmium Red

Cadmium Scarlett

Sennelier Aliz. Crimson + Burnt Sienna + Winsor Blue

Vase

+ Winsor Blue

Rose flower under glaze: Gamblin Napthol Red (Yellow Shade)

+ Titanium white

Cadmium Scarlett + Cadmium Yellow Pale

COLOR PALETTE

Titanium White	Gamblin Napthol Red (Yellow Shade)	Winsor Blue
Cadmium Yellow Pale	Cadmium Scarlett	Grumbacher Thalo Green (Yellow Shade)
Transparent Yellow	Cadmium Red	Viridian
Transparent Yellow Oxide	Sennelier Alizarin Crimson	Sap Green
Burnt Sienna	Rose Dore	Ivory Black

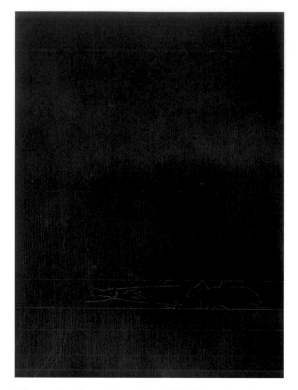

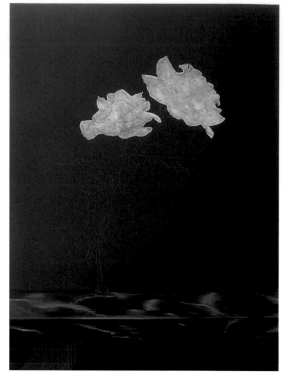

The toning layer is a mix of Viridian, Sap Green, and Ivory Black. I used Liquin and Sansodor (the Winsor & Newton solvent) to thin the paint.

The background is a mix of Cadmium Yellow Pale, Ivory Black, and Underpainting White. I mixed Liquin into the paint as I picked it up from the palette.

The marble is a mix of Thalo Green (Yellow Shade), Transparent Yellow, Ivory Black, and Titanium White. I used the transparent colors to make the green Mother Color, and then was able to use the Mother Color later for the glazing.

I always want the flowers or fruit to be the focal area of my paintings. The white base not only keeps the background from graying or influencing the flower colors, it also makes the flowers more luminous than the leaves, which are painted directly on the background. Sometimes to make one thing more beautiful

you have to make other things less beautiful, so in this case I did not give the leaves the same reflective white undercoat that I gave the flowers or fruit. When the background was dry I undercoated the rose shapes with Titanium White and just a touch of Liquin.

The first layer of glaze on the rose was a warm red. I love the way this layer can glow through the following opaque layers and influence them. The colors of these flowers, the light reds and oranges, were a challenge for me to paint as beautifully as I wanted. I would mix them to be what I thought was the exact color

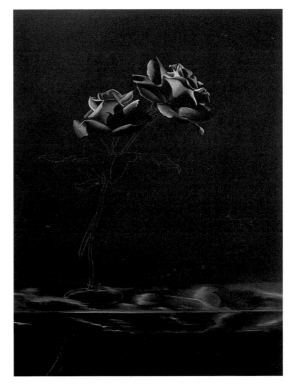

Once the white base layer was dry, I painted the rose with a layer of a transparent warm red, Gamblin Nathol Red (Yellow Shade).

I used reds of different intensities and values to capture the rich and varied coloration of the rose petals.

of the flower, but then the painted flowers wound up looking chalky and dead. When I came across this transparent under/opaque over technique it seemed like the perfect solution because the colored underglaze will bring the opaque colors to the liveliness that I want.

One of the keys to painting these flowers was to mix a lot of different intensities and values of the reds. In addition to the colors that I mixed on the palette, I did a lot of brush mixing between the colors on my palette to get the *exact* colors that I wanted.

(Brush mixing is using the brush to mix colors on the palette.)

I was very pleased with how these roses turned out, so I did not do any layers of glazing, but it certainly could have been a possibility.

HELPFUL HINT
The colors in these roses are very warm, so I chose to use Sennelier brand Alizarin Crimson because it is quite a bit warmer than the same color name by other manufacturers.

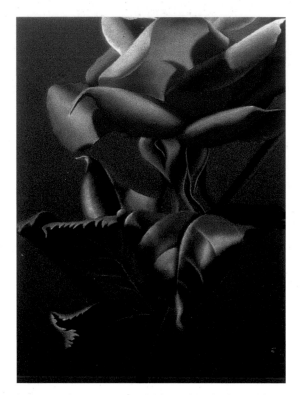

Historical painters would have blocked in the green of the leaves, but I did not. I painted them with greens that are opaque. Rose leaves can be very shiny and reflective and when I need to build highlights like these I find that using opaque colors works out very well.

I glazed the marble using the transparent Mother Color. I used two layers of glaze to create the depth of color and transparency of marble. In each layer I added more Ivory Black to the Mother Color to build the dark and shadow areas.

I used two series of mixes for the leaves. The cool set of mixes is Cadmium Yellow Pale, Winsor Blue, and Ivory Black lightened with Titanium White and more Cadmium Yellow Pale.

For the warm series of mixes, the Mother Color is a mixture of Cadmium Yellow Pale, Winsor Blue, and Sennelier Alizarin Crimson. I added Titanium White to lighten the mix. For the shadow areas I added more Sennelier Alizarin Crimson to the Mother Color to dull it and then darkened it by adding more Winsor Blue and Ivory Black.

When painting transparent colored glass, it is best to use transparent colors. This vase is a medium value, warm violet color. For a darker colored vase I would have used more layers of transparent color.

I painted the vase with a mixture of Sennelier Alizarin Crimson, Burnt Sienna, and Winsor Blue. It took one layer to paint most of the vase, however the rim and edge of the foot are darker, so they required two layers of paint. I used Titanium White for the highlights, which I blended into the transparent, wet color. When those were dry, I painted more white into the center of some of those highlights to make them brighter.

I painted the table leg with a mixture of Sennelier Alizarin Crimson and Burnt Sienna, and added Winsor Blue to the mix for the shadow areas.

HELPFUL HINT
As I lighten greens, I usually add some yellow to keep the color from looking chalky.

opposite:
Summer Magic
**Oil on hardboard,
24 x 19 inches
Private Collection**

**The completed
painting.**

CHAPTER FIVE

Inspirational Projects

Party Girls
Oil on hardboard, 33 x 39 inches
Collection of Candice Philbrick and Donna Wholey

Each flower has its own unique beauty and character, and that is what I try to capture in my paintings. Tulips often bend toward the light as they open. To me, their flared-out petals look like party dresses. I chose this vase because I liked the movement of its lines and how the light danced through the glass. This is the most intricate piece of glass I have ever tried to paint. It took about two weeks, but in the process I found a new way to make highlights sparkle and I felt a fabulous sense of achievement.

Alstromeria

Forms that have several different colors on them can be difficult to paint using the alla prima technique—the underpainting and glazing technique makes it so much easier. Since the values are worked out in the underpainting layer, the colors can be glazed on top and blended together without concern for blending different colored shadow and light areas.

Alstromeria flowers come in a rainbow of colors—sometimes there is even a rainbow of colors in each little petal! Unfortunately, the wide spectrum of colors coupled with their diminutive size can make painting these flowers challenging. I chose to paint white flowers with pink, yellow, and burnt sienna markings, but the same process could be used to paint any combination of petal colors. When painting, either pick the lightest petal color on the palette and use it for a colored underpainting and then glaze the other

colors on top, or do a neutral underpainting and glaze the colors over it.

The white flowers were underpainted using values of gray. (The Old Masters often chose to use a gray underpainting.) When using a neutral underpainting, I use browns for paintings that will be mostly warm, and gray when cool colors will prevail.

For the background, I mixed Titanium White with Ivory Black to create several values of a cool gray. After experimenting with several different whites to find the white that works best for creating softly graded backgrounds, I found Titanium White consistently has the best results. The other whites that I have tried, Gamblin Flake White Replacement, Winsor & Newton Underpainting, and Foundation Whites just don't blend as seamlessly as Titanium White. The problem with Titanium White, though, is that it is a relatively slow drying color. And

I decided to gradate the toning layer from a bright, cool pink to a dark, cool blue-violet. The color changes in the same way that I wanted the light to change on the opaque background color. The light, bright pink is Permanent Rose. I mixed that color with Holbein Mauve to cool and darken it, and then added French Ultramarine to the Mauve for the lower left corner. (Winsor & Newton Permanent Mauve is very similar to the Holbein Mauve.) I mixed Gamblin Galkyd medium into the transparent colors to accelerate the drying and to make them more transparent.

The background was painted using Titanium White mixed with Ivory Black to create several values of a cool gray. I transferred the outline of the pedestal to the background using white transfer paper and painted the pedestal and shadow of the vase using different values of the background mixture.

building a stable painting requires that the early layers of paint be more quick drying than the later layers. Otherwise the later layers can dry more quickly than the earlier ones, which can cause cracking. So, to circumvent the problem, I make sure to use alkyd medium with the Titanium White to hasten drying time. I use enough medium so that the paint moves and blends easily, but not so much that it is transparent and slippery. I place the tip of my brush into the puddle of medium on my palette, and then pull some paint out of its pile and brush the two together on the palette until I am happy with the consistency.

TIPS ON LINEWORK
Hold the brush at a 20-degree angle. The more pressure you place on the brush, the thicker the line will be, so stay up on the tip. When the paint no longer flows off of the brush, reload it. Lines are easiest to make when you pull the brush toward you. Rotate your painting so that you are moving your hand and arm in that direction.

Alstromeria Palette

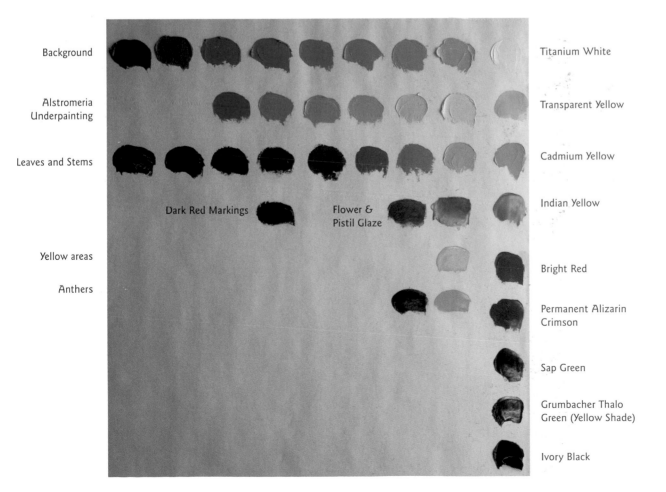

Background — Titanium White

Alstromeria Underpainting — Transparent Yellow

Leaves and Stems — Cadmium Yellow

Dark Red Markings Flower & Pistil Glaze — Indian Yellow

Yellow areas — Bright Red

Anthers — Permanent Alizarin Crimson

Sap Green

Grumbacher Thalo Green (Yellow Shade)

Ivory Black

The underpainting for the flowers was mixed using Permanent Alizarin Crimson, Grumbacher Thalo Green (Yellow Shade), and Titanium White. Permanent Alizarin Crimson (or Alizarin Crimson) mixed with Thalo Green (Yellow Shade) makes a gorgeous black that has tremendous depth; far more than a tube black such as Ivory Black or Mars Black. And mixed with white it creates a variety of grays. Here I just couldn't resist allowing the gray to be just a little bit pink, just enough to differentiate it from the gray of the background. (The brush was tipped in Galkyd before picking up paint.)

The stems and leaves were painted using a mix of Thalo Green, Cadmium Yellow, Permanent Alizarin Crimson, and Titanium White. Thalo Green is a very intense color and for painting naturally colored leaves and stems it usually should be dulled with another color. The Cadmium Yellow is more of a yellow-orange than a true yellow, so it dulls the green some, and the Permanent Alizarin Crimson dulls it even more.

The clear glass vase was painted using the background colors and very small brushes. All of the tiny details in this vase required using round brushes, sizes 2, 10/0, and 18/0. Linework this fine can be challenging to paint. (See Linework, page 38, and tip box on page 117.)

The first layer of glaze for the pink areas was Bright Red mixed with Galkyd. Directly out of the tube, the paint looks *very* bright, but

I transferred the outlines of the flowers to the background with white transfer paper. I used Titanium White, with medium, to undercoat the flowers. Sap Green and Sap Green mixed with Transparent Yellow were used for the green areas. Titanium White was used to enhance the highlights on the vase.

HELPFUL HINT
The pedestal that the vase of flowers is setting on was drawn using one-point perspective.

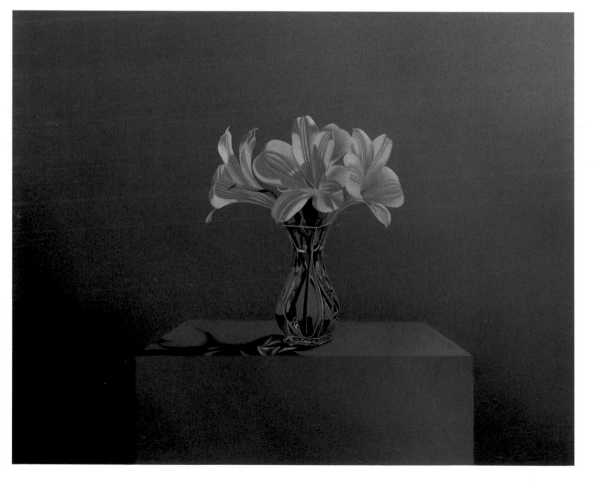

when it is thinned out a lot with the medium it lightens up to a lovely pink. Transparent Yellow mixed with a little bit of Indian Yellow and Galkyd was used for the yellow areas. For the green stem area of the right flower, I used the green mixes from the leaves mixed with a little bit of Galkyd. In some areas the pink was feathered into the adjacent light pink and white areas.

Sometimes at this point in a painting I find that I am feeling disappointed in how the image is turning out. Usually the problem is that the colors are not intense enough yet or the value structure isn't strong enough. I decided that in this painting, both were true.

I wanted to reinforce the illusion of light, so when I glazed the bright pink areas with another layer of Bright Red, I emphasized the shadow areas with a glaze mix of Bright Red and Sap Green. I have not yet painted the pistils and stamen. Since they are such small structures I decided that the glazes would be smoother if they are painted when all of the glazing is completed.

Another glaze of Transparent Yellow and Indian Yellow was added to the yellow areas of the center and right flowers. The dark red marks were added to the petals using a mix of Permanent Alizarin Crimson, Bright Red, and Thalo Green.

On the pedestal the illusion of light wasn't working very well, so I painted the top front edge with the lightest gray mixed with Titanium White.

The illusion of light on the flowers was not as convincing as I wanted it to be, so I adjusted the shadows and highlights in the subsequent layers of glaze.

HELPFUL HINT
All of the colors in this layer were mixed with a small amount of Galkyd.

Some of the pink shadow areas were darkened a little bit more with the Bright Red-Sap Green mix. Then the pistils were undercoated with Titanium White and the anthers (pollen sacks) were undercoated with a mix of Sap Green, Indian Yellow, and Bright Red to establish their value. Their color is a dull yellow-green and, especially at this stage in the painting, it is important to use colors that have already been used within the painting. It helps to keep harmony and unity within the composition. All of the above colors were mixed with a small amount of Galkyd medium.

To complete the painting, some of the lightest lights on the petals got lost, so I reinforced them with a layer of Titanium White that was feathered into the adjacent areas. Another layer of dark and light was painted on the anthers, and some darks were added to the pistils with a mix of Bright Red and Sap Green.

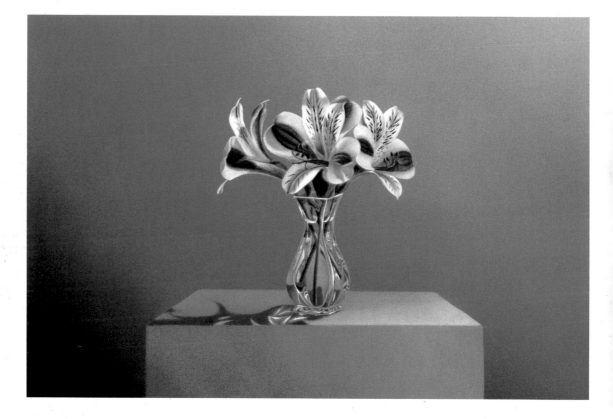

The pistils were glazed with Bright Red and a mix of Bright Red and Sap Green. The anthers were painted with the same color as for their undercoat, and for the lightest areas that color was mixed with Titanium White. See how the toning layer comes through the opaque background and unifies it with the rest of the painting.

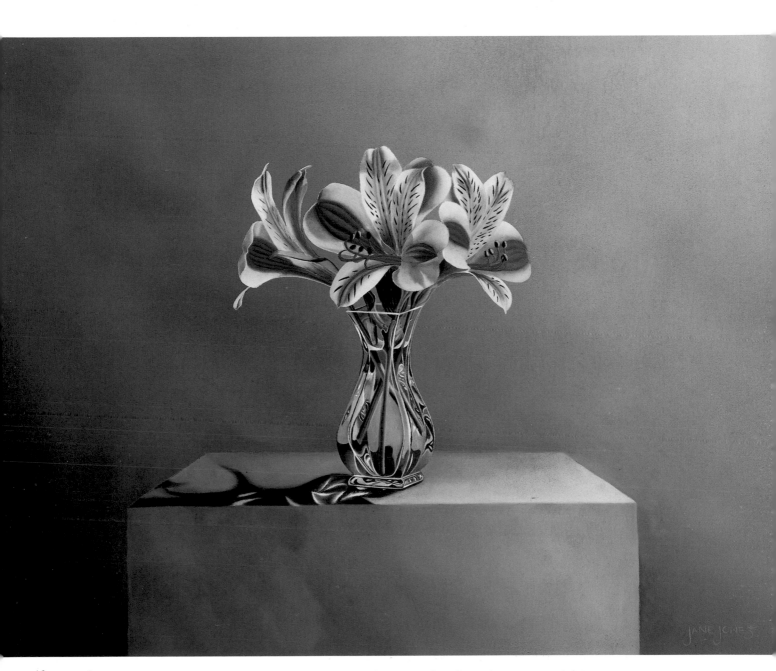

Alstromeria
Oil on hardboard, 12 x 15 inches
Private Collection

The completed painting.

Autumn Flame

I love fall leaves. When looked at individually, each leaf is a composite of a myriad of colors, each in itself a tapestry of fleeting beauty. With so many different colors, the underpainting and glazing technique is a perfect choice for painting fall leaves. The form and lighting of the leaf can be established in the underpainting, and then the colors can be added in transparent layers.

I started with a toning layer of several colors, including Indian Yellow, Gamblin Napthol Red (Yellow Shade), and Permanent Alizarin Crimson all softened together. I used these colors to give a fiery foundation to the transparent brown background I planned to use. Liquin was added to each of the colors.

The first layer of the background color is brown mixed by using Indian Yellow, Purple Madder, and Sap Green. I mixed it to be a little bit red-violet. Liquin was added to it to thin it, make it dry faster, and for the stability of the paint film.

The second layer for the background is the same as the first. The shadow color is the same mix, but with a bit more green, and I added French Ultramarine to cool and darken the mix. (Liquin was added to this layer.)

Titanium White with a little bit of Liquin was used to undercoat the shape of the leaf. (The underpainting sequence is on page 124.)

It's useful to use a warm and a cool of each color, so onto my palette I squeezed out some Transparent Yellow (the cool yellow), Indian Yellow Deep, Bright Red (the cool red), Gamblin Napthol Red (Yellow Shade), Sap Green (the cool green), and Green Gold. Rather than mixing colors using a palette knife, I just used the brush to mix together colors in a more random way. And, of course, the brush was tipped in Liquin as the medium to make the colors lighter and for the stability of the layer.

For the final layers, some of the areas where I painted Permanent Alizarin Crimson were too bright, so Sap Green or Indian Yellow Deep was glazed over some of those areas to dull them. I used Sap Green only in the darkest areas of the shadows.

The shadow cast by the leaf was not dark enough, so on all but the right side of the shadow I added a glaze of French Ultramarine. Compared to the other colors in the painting it is quite cool, which creates more contrast and therefore more drama.

The toning layer has a beautiful variation of color, much like the leaf itself.

The background is a dark, rich brown that leans toward red-violet, lending an extra hint of warmth.

Autumn Flame Palette

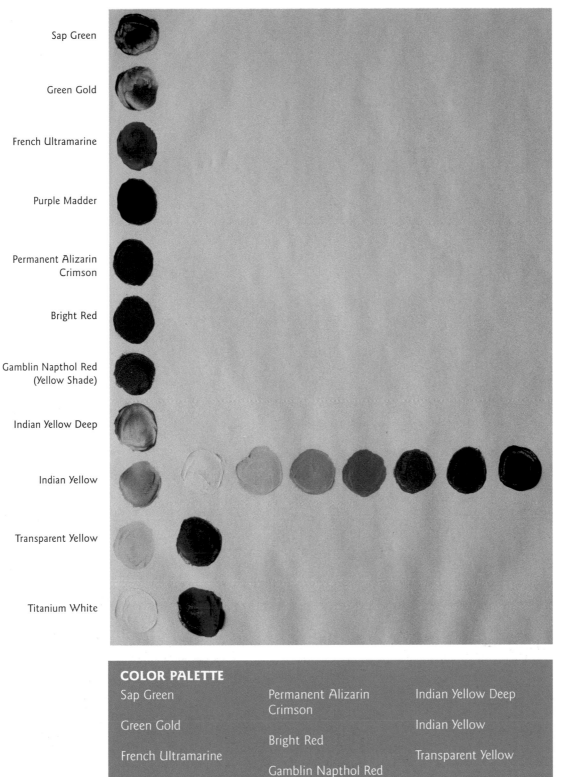

Sap Green

Green Gold

French Ultramarine

Purple Madder

Permanent Alizarin
Crimson

Bright Red

Gamblin Napthol Red
(Yellow Shade)

Indian Yellow Deep

Indian Yellow — Underpainting / Mother Color

Transparent Yellow — Background Shadow

Titanium White — Background

COLOR PALETTE

Sap Green	Permanent Alizarin Crimson	Indian Yellow Deep
Green Gold	Bright Red	Indian Yellow
French Ultramarine	Gamblin Napthol Red (Yellow Shade)	Transparent Yellow
Purple Madder		Titanium White

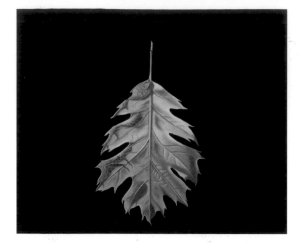

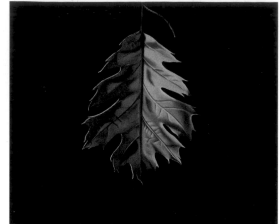

For the underpainting of the leaf I mixed Sap Green, Purple Madder, and Indian Yellow Deep to make a brown. Indian Yellow Deep is a beautiful transparent yellow-green. The brown created using it is subtly different than one created using Indian Yellow. And then that brown was mixed with Titanium White to create a series of values.

The darks were enhanced with a glaze of the underpainting brown Mother Color. The brush was tipped with Liquin before picking up the paint. This deepening of the darks could have been done with colored glazes, but I just really like to see the complete value structure in the underpainting.

I glazed one half of the leaf with color. I loved the underpainting so much that I thought about glazing it just lightly with the transparent brown and letting it be a "brown" leaf. But seeing the underpainting side by side with the first layer of glaze, I see how exquisite the colors are and how chalky the underpainting really is.

Whenever I begin the first layer of glaze the color usually seems rather intense. That is because of the contrast between the glaze colors and the dull underpainting. By the time I get the first layer of glaze over everything, I am usually thinking that it all looks rather dull. Color is so relative and dependent upon it's surroundings.

The first layer if glazing was completed on the other side of the leaf. A small piece of soft paper towel was used to lift excess pigment from the lightest areas. It is much easier to add more pigment later than to reestablish the lights once they have been painted over.

Another layer of color mixed with Liquin was glazed over all of the leaf. Permanent Alizarin Crimson was added for the dark red areas. Some of the lightest and warmest areas of green and red from the previous layer were left visible so there would be more variety in the colors.

Autumn Flame
**Oil on hardboard,
14 x 12 inches**

I am pleased with
this painting, but
when I paint another
autumn leaf, I will
paint a very thin
glaze layer of Indian
Yellow over the
underpainting to add
more warmth and
fire to the colors.

CHAPTER SIX

Finishing Touches

Cranberry Etude
Oil on hardboard, 9 x 12 inches
Private Collection

I found this blossom on my favorite rose bush and placed it in this simple vase that complements the flower's colors. When painting a flower, I try to find the lighting and composition that presents the bloom in the most interesting and beautiful way. While backlighting can be a little bit tricky to paint, the effect is usually quite dramatic. The tabletop or pedestal serves as a stage on which the lighting is as much an actor as the objects themselves.

Varnishing

Varnishing is the final step in creating a stable painting. Unfortunately, over the last 100 years or so many artists have chosen not to protect their paintings with varnish. Still, the products available today are so much better than the ones previously offered, and they are easier to use. Natural resins, such as Damar, can eventually become cloudy and yellow and darken or crack. They can also be difficult to remove without disturbing the paint layers. Fortunately for artists today, companies have researched their chemistry thoroughly in order to manufacture reliable varnish products. The more modern synthetic varnishes, such as the one described here, remain crystal clear and are specifically formulated for easy removal.

When to Varnish

One of the big questions about varnishing an oil painting is "When is it safe?" The traditional answer is six to twelve months after the painting is completed, while the more practical answer is "when you can run a cloth with solvent in it over the surface of the painting without lifting any paint." Of course this is done on a discrete corner or edge of the painting. Bob Gamblin of Gamblin Artists Colors says, "Some paintings are dry enough to varnish in two weeks. If you paint thinly with fast drying colors using a fast drying (alkyd) medium, in a warm and dry climate, then the painting may be ready to varnish in two weeks. Some paintings may not be dry enough to varnish after two years. If you painted with Alizarin Crimson in a layer a quarter-inch thick (using a slow drying oil), then the painting may not be ready to varnish in two years, if ever. In general we recommend painters using alkyd resin painting mediums wait three months before varnishing."

Keeping in mind that the varnish should be removable, it should not be brushed onto the painting until the paint is dry. A common misbelief among many artists is that if the paint is still wet when it's varnished then the paint and varnish can dry together. But the truth is that they dry at different rates. The varnish can slow down the drying process of the paint and eventually the tension between the two can become so great that the surface of the painting cracks. The other problem that can occur is that the varnish becomes chemically

THREE REASONS TO VARNISH A PAINTING

1. The varnish layers protect the paint layers. Over time, dust, smoke, and other environmental pollutants can come to rest on the surface of the painting and, to various degrees, obscure the painting. If a layer of varnish is on the surface of the painting, then it can be cleaned or removed to restore the original look of the painting. So the varnish should be removable without damaging the surface of the painting.
2. Varnish creates an even sheen over the surface of the painting. When dry, some paint colors are glossy and others are more matt. The amount of medium in the paint also affects the sheen. Liquin and Galkyd cause paint to dry with a bit of gloss, but not all colors will be affected the same way. Varnish will even out the shine of the surface.
3. Varnish can beautifully saturate or deepen the colors of a painting. An example of what varnish does for colors can be imagined by thinking about river rocks: When the rocks are in the water their colors look more saturated and brilliant than when they are dry. Varnish makes that same difference on an oil painting: the colors look more saturated.

bound to the paint and should the varnish then be removed, some of the paint will go along with it.

Oil paint doesn't dry by releasing water. It actually dries through a chemical process called oxidation. As oxygen molecules from the air are incorporated into the oil binder, the molecules of oil bind with the oxygen and more tightly to each other creating a tough film that binds the pieces of pigment together. For the oxidation process to occur the paint film needs air and a premature layer of varnish prevents the air from reaching the paint surface.

Which product?

At this point in the painting process, there is so much invested in the painting that it is not worth taking any chances. As mentioned before, I think it is important to use chemistry from the same manufacturer throughout the whole painting process, and that includes the varnish. So, if I have used Winsor & Newton's Liquin throughout the painting, then I use that company's varnish. The Winsor & Newton varnish that I prefer is called "Conserv-Art." It is available with either a gloss or matt finish. I like to mix the two

together to create a satin finish, using three parts of gloss and one part of matt. (Matt varnish is dull because it has wax mixed into it.)

If I have used Gamblin's Galkyd throughout the painting process, then I use their "Gamvar Picture Varnish." Mixing the varnish up requires a bit more effort, but then you know how fresh it is, and some believe that varnish is most stable when it is most fresh.

Gloss or Matt Finish?

The reflectivity (shininess or dullness) of the varnish can be controlled to suit personal taste. It can be very shiny or very dull, or somewhere in between. The shinier a varnish is, the clearer it is. The problem with a very shiny or glossy surface is that it can reflect so much light (glare) that the painting is difficult to see. Wax is the dulling agent in matt varnish. Using too much matt varnish will cause the surface of the painting to look cloudy. My preference for varnish reflectivity is a satin finish, which is somewhere in between gloss and matt. I mix just enough of the wax or matt varnish into the gloss varnish to keep it from creating too much glare.

I use three parts of Conserve-Art gloss varnish to one part Conserv-Art matt varnish. An easy way to make this ratio is to use a clean, small glass jar (from artichoke hearts) and mark on the side with a paint pen at 1/4-inch intervals. Then pour in gloss varnish up to the third mark and matt varnish up to the fourth mark. Mix thoroughly with a disposable utensil, such as a plastic knife or spoon or a wooden craft stick or tongue depressor. Be sure to mix up enough varnish to cover the painting with two layers.

What kind of brush?

A big, fluffy round brush is the best kind of brush to use for varnishing a painting with a smooth surface. I use an oval mop brush, but a watercolor sky wash brush works well too. A soft brush is less likely to leave "brushmarks" than a stiffer brush.

The varnish brush should only be used for varnishing, so that it won't be accidentally contaminated with pigment or another chemical. When you finish applying the varnish, clean the brush right away in clean solvent (one from the same company as the varnish). Then wash the brush with soap (I prefer Murphy's Oil Soap) to remove any solvent residue. When the brush dries it can be fluffed out.

Where to varnish

Varnishing should be done in a well-ventilated area that is as free of dust as possible. I varnish in my studio and then place the painting in a room that we don't use much (one of my friends uses a shower stall in a guest bathroom). The space just needs to be dust-free (or at least not recently stirred up). Do not be tempted to place a fan in front of the painting to hasten drying time, as anything in the air will fly directly into the fresh varnish.

The painting should be laid flat while the varnish is drying. If it is upright, then the varnish will "sag" and be heavier at the bottom of the painting. As soon as the varnish is dry to the touch, it can continue drying in a vertical position.

The workspace needs good direct overhead illumination. You should have the ability to manipulate the direction of the light source, such as with a swing-arm lamp. The most important element in successful varnishing is glare. While glare is very distracting when you are painting, when varnishing, glare will show where the varnish is and is not, its thickness, and will reveal any debris or brush hairs that are embedded in the wet varnish.

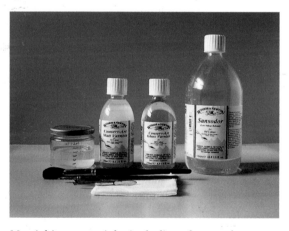

Varnishing materials, including gloss and matt varnish, solvent, brushes, tweezers, and tack cloth.

VARNISHING MATERIALS
- Varnish (premixed)
- Brush (large, fluffy round brush)
- Solvent
- Tack cloth (tack cloths can be purchased at hardware stores)
- Small brush (for lifting up debris or brush hairs)
- Tweezers (after lifting debris or brush hairs with the small brush, use tweezers to pull it free of the wet varnish or to remove the items from the brush itself)

The Process

Do not be intimidated by the varnishing process. If you can create a painting, you can varnish it. It is a bit intimidating to take a painting that you have invested a lot of time and thought into creating, and then add on a product that you are not familiar with. For this reason, before you begin varnishing a completed painting, I recommend that you practice on some boards that have been prepared and then painted with one layer of paint (the paint should have some medium in it). This way you will get the *feel* of the varnish as it is brushed over a surface similar to that of your painting. Practice with varying amounts of wax in the varnish to determine the best look, and be sure to make notes as you go. Keep in mind that you will not really know what the varnish looks like until it is dry.

1. *The first step is to make sure that the surface of the painting is free of any small particles of dust or debris, or any loose brush hairs. Do not try to remove anything that might leave a mark in the painting once it is gone. Wipe the surface of the painting with a tack cloth, which can be purchased at a hardware store. (Tack cloth is basically a piece of lint-free cloth that has been treated to make it sticky.) Pay special attention to removing debris from the edges of the board or canvas, as they are the chief source of contamination when brushing on the varnish.*

HELPFUL HINT
Be sure to have all of the materials collected before you start to varnish.

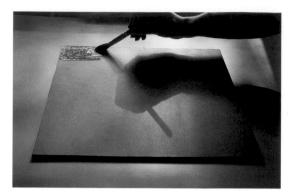

HELPFUL HINT

Be sure to mix the varnish thoroughly. The particles of wax need to stay evenly suspended in the mixture or streaking will occur.

2. Varnishing is done in a series of small rectangular areas, the size and shape of which depend on how much surface you can cover with one brushload. To begin, place the painting so that its longest dimension is perpendicular to your body (varnish across the shortest dimension to maintain a wet edge). Adjust the light source to provide the needed glare. Dip the brush into the varnish mixture, swirl it to mix, and then use the edge of the jar to remove the excess. Position the brush in the middle of the first varnishing area.

3. Pull the wet varnish out from the center of the varnishing area and immediately look in the glare for any debris embedded in the surface. It is also important to look at the wet varnish without glare just in case there are brush hairs or debris revealed in that lighting.

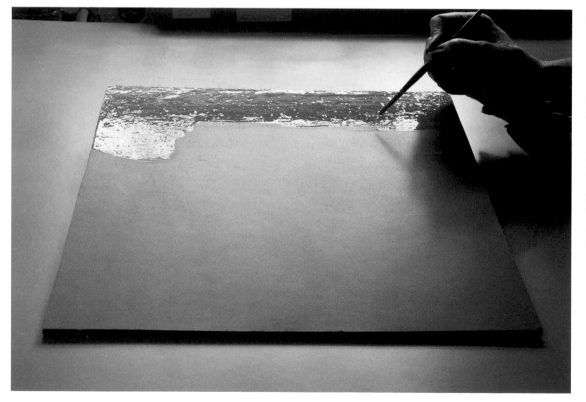

4. Use the small brush to lift any debris or brush hairs, and the tweezers, if necessary to grab them from the brush. Don't worry when you see air bubbles in the varnish. The varnish is formulated to release air bubbles as it dries. Still, it is impossible for all of the air bubbles to release, so there will be a few in the dried varnish.

It's best to use two thin layers of varnish rather than one very thick one. Thin layers dry more quickly and evenly, and are more likely to release air bubbles. They also dry to a harder finish.

In general, two coats of varnish look really great. Additional coats run the risk of embedding more foreign material into the final finish. The first coat will dry the most slowly and is the best opportunity to remove hairs from the surface of the painting. The second coat acts partially as a solvent for the first coat, and therefore must be applied quickly if it is to be applied evenly. With the second coat there is just enough time to remove brush hairs or a particular foreign object, but nowhere near as much working time as the first coat. The longer the first coat dries, the more time you will have to apply the second coat.

When applying the second coat, it is more difficult to keep the thickness of the wet varnish uniform. The less time a wet varnish edge spends drying before overlapping another wet edge, the easier it will be to make a smooth transition.

Note: If the painting is large, begin varnishing in the lower left corner and work your way upwards to the middle. Then, rotate the painting 180 degrees, and varnish from the middle downward. This way, you don't have to reach over the wet varnish for the second half.

HELPFUL HINT

David Pyle from Winsor & Newton says, "Get an even coat quickly and efficiently and then leave it alone. As the first area of varnish begins to dry, it will look just a little bit different than the just brushed-on area—don't be tempted to go back and rework the wet surface of the earlier area. When the whole layer is dry, it will all look the same."

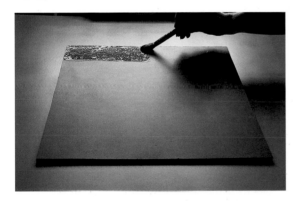 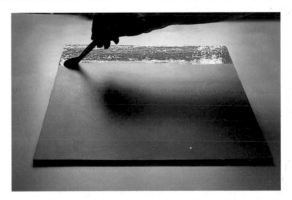

5. *Reload the brush with varnish, remembering to swirl the mixture each time. Move on to your next area, moving from left to right and from top to bottom (if you are left-handed, work from right to left). Check in the glare to make sure the varnish is completely covering each area before you move on to the next.*

6. *Paint a narrow strip of varnish across the entire painting in order to keep the leading edge of the varnish wet. Then start another row on the left and work to the right. (Left-handed people should move from right to left.) When the first layer of varnish is dry to the touch, you can add a second layer.*

Removing Varnish

At this point, many types of surface damage, such as *very* shallow scratches that do not penetrate to the paint surface and scuffs, can be solved with a new coat of varnish.

Scratches that have any depth to them cannot be repaired with a new coat of varnish because varnish is "self leveling," which means it levels out to follow the contours of the surface of the paint—any significant valleys in the surface will be matched by the varnish. So if the scratch has any depth, it is best for you to remove the old varnish and reapply it. To remove varnish, soak pieces of cheesecloth in the appropriate solvent and gently rub the surface in a swirling motion. The varnish will respond by becoming gummy and forming little balls. Continue rubbing lightly with fresh solvent-soaked cloths until all of the varnish has been removed.

HELPFUL HINT

If you have any problems with their products, experts at both Winsor & Newton and Gamblin (as well as other companies) are available to help over the telephone. Check product labels or look for their customer service numbers in the resources section of this book.

Garlic
**Oil on hardboard,
5 x 10 inches
Collection of
Randall C. Fraser**

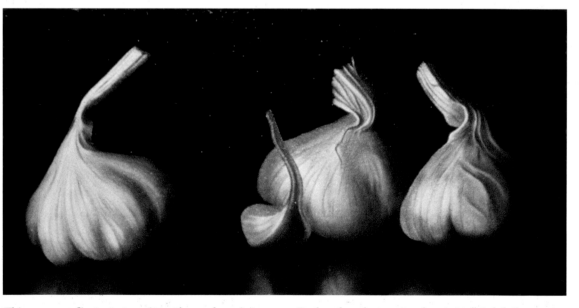

This was my first venture into the underpainting and glazing technique. I loved how much control I had with the value structure and the richness and luminosity of the transparent browns.

Dark colors have a tendency to "sink in" or get very dull and flat. Aesthetically the varnish is important because it brings them back to life and evens out the reflective quality of the surface of the painting.

Framing

Framing is an important last step whose primary function is to protect the painting. Hardboard in particular should be protected with a frame because the corners of the board are fragile. If the painting is dropped on a corner, the corner can easily break or scrunch up, which could harm the painting.

The other function of a frame is to enhance the appearance of the art. Which frame looks best is a very personal decision, determined in part by the image itself, our personal likes and dislikes, and where we plan the painting to ultimately be hung. In my view, you can frame a painting to go to the "prom," or you can frame it to go to the "grocery store." I always opt for the former, but then again my paintings are usually more formal and elegant.

While there can be many frames that work well with a painting, there always seems to be one that *really* sings with it. For this reason, I recommend exploring a variety of framing options to find the one that looks just right. When choosing a frame, be sure that the frame does not overpower the painting. The frame's job is to accentuate the painting, not take anything away from it. You don't want people to notice the frame first and your painting second.

Professional framers know a lot about designing frames, so I would recommend visiting a frame shop and consulting with one of the store representatives. Take your painting to more than one framer and get more than one opinion. They all have their biases and one might be more appropriate than another for both your tastes and your budget.

Casa Blanca Lilies
**Oil on hardboard,
26 x 32 inches
Collection of
Krys Moore and
Tom Green**

**This frame seemed
like the right choice
for this painting
because it has
a lovely rounded
profile that echoes
the contours and
movements of the
flowers and glass.**

CHAPTER SEVEN

Closing Thoughts

The Messenger
Oil on hardboard, 24 x 36 inches
Private Collection

When an object is as solitary as this tulip, it has to be perfect; the whole painting is dependent upon it. Painting the flower became a struggle for me. After painting it twice, I still wasn't happy with it, so I gessoed several small pieces of matboard, painted each one with the background color, and then painted each one with a different underpainting and glazing combination. Then I decided which version worked best within the composition.

Finding Your Creative Style

Just as each one of us has a distinctive speaking voice, each one of us has a personal voice with a brush. Use this wonderful painting process to spark your imagination and creativity—experiment to find *your* way and *your* voice. Trust your ideas and listen to the quiet voice inside of you. Not every painting will be successful, especially if you experiment. But follow the accidents and impulses, explore them—they just might be guiding you toward the creative expression that is uniquely your own.

In this section, I would like to share with you a selection of some of my finished paintings that were achieved following the underpainting and glazing process described in this book. Each painting presents its own set of challenges and revelations. I hope by sharing some insights into my creative process, I can help you discover your own creative voice.

right:
Three Oriental Lilies
**Oil on hardboard,
25 x 25 inches
Private Collection**

We grew these marvelous lilies in our garden. I am absolutely in awe of their transformation from ugly, rough bulbs to extravagant, smooth beauties. Their yellow throats form a star within the blossom, which I find amazing. The simple contours and subdued color of the vase are quiet and subtle compared to the energy and movements of the petals.

opposite: ***Whistlin' Dixie***
**Oil on hardboard, 28 x 20 inches
Private Collection**

The genesis for many of my paintings occurs when the gardening catalogues arrive in the winter. The photographs are so luscious and compelling. Every year I order new color combinations of favorite flowers and dream of the possibilities....

above: *Orchard Alcove*
Oil on hardboard, 19 x 23 inches

Years ago my husband I decided to plant several fruit trees in our backyard. Last summer we had fabulous fruit on every tree, so I decided to take advantage of that rare event and paint some of the fruit. The leaves make the fruit look especially fresh and alive, and add a great deal of character to the image.

opposite: *Hello Sunshine*
Oil on hardboard, 23 x 17 inches
Collection of Otto and Marilyn Wolter

The underpainting and glazing technique was perfect for adding the pink blushes and shadows to this basically white flower. By working in layers, the white and red areas did not blend and instead remained distinct.

Explore your interests and passions to discover the creative inspiration that is there for you to find. Painting is really hard work and *passion* is what will sustain you through the various challenges, difficulties, and sometimes long hours that a painting requires. Use this book as a step to realizing *your dreams* and to finding the artistic expression that is truly, and only, yours.

Peaches and Strawberries
Oil on hardboard, 10 x 16 inches

This was one of my first paintings with this technique and I was thrilled with the results. I love the softness of the peach in contrast to the irregularities of the shiny strawberries. This was also the first painting on which I used a brush on varnish, and seeing how the varnish brings the image to life made me a firm believer.

Resources

Gamblin Artists Colors Co.
 1.503.235.1945
 www.gamblincolors.com

Winsor & Newton / Col Art Americas, Inc.
 1.732.562.0770
 www.winsornewton.com

Note: Most manufacturers sell their products to retail and on-line stores. If you can't find a store in your area that carries a particular item, or will accept a request for an order, or if you need special assistance, a manufacturer will direct you to the retailer nearest you that carries their products and will try to answer any technical questions you might have.

Select Bibliography

Cooke, Hereward Lester, *Painting Lessons from the Great Masters.* Watson-Guptill Publications, 1972.

Davies, Ken, *Ken Davies: Artist at Work.* Watson-Guptill Publications, 1978.

Davies, Ken and Ellye Bloom, *Painting Sharp Focus Still Lifes: Trompe L'Oeil Oil Techniques.* Watson-Guptill Publications, 1975.

Haak, Bob, *The Golden Age: Dutch Painters of the 17th Century.* Stewart, Tabori and Chang, 1996.

Harris, Ann Sutherland and Linda Nochlin, *Women Artists. 1550 - 1950.* Alfred K. Knopf, 1997.

Mayer, Ralph, *The Artist's Handbook of Materials and Techniques,* fourth ed. The Viking Press, 1981.

Pech, Arleta, *Painting Fresh Florals in Watercolor.* North Light Books, 1998.

Pyle, David, *What Every Artist Needs to Know About Paints and Colors.* Krause Publications, 2000.

Sheppard, Joseph, *How to Paint Like the Old Masters.* Watson-Guptill Publications, 1983.

Wallert, Arie, *Still Lifes: Techniques and Style.* Waanders Publishers, 1999.

Wheelock, Jr., Arthur K., *Dutch Paintings of the Seventeenth Century.* Oxford University Press, 1995.

Author contact:
Jane Jones
P. O. Box 740011
Arvada, CO 80006-0011
www.janejonesartist.com

Index

Alstromeria *See*
 Underpainting and
 Glazing
Autumn Flame *See*
 Underpainting and
 Glazing
Camera Obscura, 12
Caravaggio, 44
Color,
 Background, 33-36, *33-36*
 Greens, 24
 Intensity, 22, 26, 40
 Mixing, 21, 22, 23, *24,*
 25, 25
 Complementary, 26,
 26, 27
 "Mother," 25, *25*
 Neutral, 26
 Notes, 51-53, *51-53*, 78
 Opaque, 20, 21, *21, 23*
 Oranges, *24*
 Primary, 22, *23*
 Temperature, 22, 40
 Tertiary, 25
 Theory, 21, 22
 Transparent, 20, 21, 22,
 22, 23, 28, *28, 29*
 Value, 22, 40
 Violets, *24*
 Wheel, 21, 23, *23, 25,* 26
 Yellows, 104-109, *105,*
 107, 108-109
Drawing, 12, 58-79
 Basic techniques, 58-59
 Edges, 74
 Ellipses, 59, 60, *60, 72, 73*
 Definition of, 60
 Drafting, 62-65, *62-65*
 Fruit Compote, 70-75,
 70-75
 Linear Perspective,
 Definition of, 68
 One-Point, 68, *68*
 Two-Point, 69, *69*
 Materials, 58, 59
 Squaring, 66-67, *66-67*
 Symmetry, 59
 Horizontal axis, 62, 63
 Vertical axis, 59, 62, 63
Framing, 135
Gentileschi, Artemisia, 44
Glazing, *See* Underpainting
 and Glazing
Imprimatura, See Support
 Preparation

Jones, Jane
 Alstromeria, 116-121, *116,*
 118-121
 Autumn Flame, 122-125,
 122,124, 125
 Casa Blanca Lilies, 135
 Cranberry Etude, 126-127
 Crystal and Lilies, 42-43
 Garden Rainbow, 90-101,
 92-101
 Garlic, 134
 Glorious, 74-5
 Golden Glory, 102-107,
 102, 104-107
 Harmony, 37, *37*
 Hello Sunshine, 141
 Illumination, 57
 The Messenger, 136-137
 Nature's Magic, 9
 On the Move, 46
 Orchard Alcove, 140
 Party Girls, 114-115
 Peaches and Strawberries,
 142
 Protected Pansy I, 5
 Protected Pansy II, 5
 Protected Pansy III, 5
 Sassy Faces, 2-3 (detail),
 14-15, 53
 Sensual Banquet, 77, 78-89,
 80-89
 Summer's Jewels, 6
 Summer Magic, 108-113,
 110-113
 Three Oriental Lilies, 138
 Whistlin' Dixie, 51, *139*
Lighting, 44-46, *44-45,*
 48-50
 Artificial, 44, 45, 46, 47
 Direction, 44, 45
 Intensity, 44, 45
 Natural, 44, 45, 46, 47
 Temperature, 44
 Tenebroso, definition of, 44
Painting Materials,
 Alkyd medium, 18, 38
 Galkyd, 18
 Galkyd Lite, 18
 Liquin, 18
 Brush cleaning pad, 17,
 17
 Brushes, 19, *19*
 Cleaning of, 17,
 18, 39
 Types of, 19

Canvas *See* Support
 Preparation
Hardboard, 16, 30, 31, *31*
 See also Support
 Preparation
Gesso *See* Support
 Preparation
Linseed Oil *See* Support
 Preparation
Medium, *See* Support
 Preparation
Murphy's Oil Soap, 18
Paints, Oil, 20, *20*
 For Underpainting,
 Flake White
 Replacement,
 20, 81
 Titanium White,
 20
 Underpainting
 White, 20
Palette, 16, *16*
 Organization *See*
 Color
Palette Knife, 16, *16*
Palette Seal, 16, *16,* 36
Paper towels, 16
Prepared surface *See*
 Support Preparation
Single-edge razor blade,
 18
Size *See* Support
 Preparation
Solvent, 17, *17*
 Gamsol, 17
 Sansodor, 17
Varnish, 17,128-134,
 How to, 128-134,
 131-134
 Removing, 134
 Conserv-Art, 129
 Gamar Picture
 Varnish, 129
 Gloss, 129
 Matte, 129
Wipe-Out Tool, 18, *18,*
 39
Techniques,
 Blending, 40-41, *40-41*
 Layering *See*
 Underpainting and
 Glazing
 Lines, 38, *38*
Photography
 Use of as painting tool, 12,

 46, 47-50, *48-50,* 70, *70*
Ruysch, Rachel, 12, 110
 Flower Still Life, 12, *13*
Still life,
 Preparing to paint a, 44-53
Support Preparation, 16,
 30-31
 Gesso, 30, 31, *31,* 32
 Ground, 30-31
 Medium, 17, 32, 40, 79
 Liquin, 79, 81, 94, 98,
 100
 Size, 30
 Toning layer, 32, *32,* 78, 79,
 94
 "Tooth," 30, 31, 32
Symbolism, 12
Tweezers, 18
Underpainting and Glazing,
 10,15, 19, 20, 78-127
 Alstromeria,
 118-123, *120-123*
 Autumn Flame, 124-127,
 124, 126-127
 Glazing, 84-91, *84,*
 86-91, 98-109, *98-*
 103
 Illustration of, 10
 Layering, 78-115
 Transparent Under,
 Opaque Over Technique,
 110-115
 Underpainting, 78-83,.
 79, 82-83
 Colored, 92-97, *94-97*
van Rijn, Rembrandt, 44
Varnish *See* Painting,
 Materials
Vermeer, Jan, 12
von Oosterwyck, Maria, 10,
 12
 Bouquet of Flowers in a
 Vase, 11